PHOTOGRAPHY CONTESTS:
HOW TO ENTER, HOW TO WIN

LIDA MOSER

AMPHOTO
American Photographic Book Publishing:
An Imprint of Watson-Guptill Publications
New York, New York 10036

Dedication

I dedicate this book to Andrea and Cara.

All rights reserved. No part of this book may be reproduced in any form whatsoever without written permission from the publisher. Published in New York, New York by American Photographic Book Publishing: an imprint of Watson-Guptill Publications, a division of Billboard Publications, Inc.

Library of Congress Cataloging in Publication Data

Moser, Lida.
 Photography contest, how to enter, how to win.

 Includes index.
 1. Photography—Competitions. I. Title.
TR147.M69 770′.79 80-29416

ISBN 0-8174-5403-9 (Hardbound)
ISBN 0-8174-5404-7 (Softbound)

Manufactured in the United States of America

Second Printing, 1981

Contents

Introduction

The purpose of this book is to present the many aspects of photo contests. Contests can serve many purposes. They may provide a valuable learning experience, stimulating creativity and inspiring technical excellence. They can generate enthusiasm, intensify sensibilities, and test potential. Contests can also provide excitement and the impetus to excel.

This book will discuss and analyze the many different types of contests, the different kinds of prizes and awards. Readers will find out directly from people who frequently act as contest judges what criteria they bring to a judging and how they view entries— what goes on behind the scenes.

Contests can give photographers the gratification and thrill that comes from winning, and also the opportunity to see their work published and exhibited.

Often contests have served people, both winners and non-winners, as springboards to professional careers. Many well-known photographers won photo contests early in their careers. In this book, some of these winners discuss their contest experiences and the valuable psychological boost they got from winning.

There is also a group of people we call the "winner-makers." These are editors and teachers who have outstanding records of inspiring and encouraging those they work with to produce prize-winning work. Their opinions, ideas, and experiences, which they discuss in this book, should be extremely helpful; and it is hoped that they will prove to be as positively influential to the reader as they are to those with whom they are more directly associated.

Besides analyzing and explaining the different types of contests, this book also presents a number of entry forms for a great variety of competitions. Reading and studying these forms should give the potential contest entrant a good, solid understanding of

what contests are all about, so that the final decision to enter a contest comes from a position of strength and knowledge.

One thing this book cannot teach is what, exactly, will win. There are too many variables involved in the final choices of award-winning photographs. However, on reading this book, the reader will come to understand what many of these variables are—and with understanding will come judgment and confidence. These are the first steps on the road to winning.

Throughout this book you will find quotes from many people involved in all the different aspects of the world of photography contests. They are judges, teachers, editors, and contest winners; all of them have been generous in sharing their ideas and experiences. Their advice should give you the understanding and the confidence needed for entering photographic competitions.

I wish to extend my deepest thanks and appreciation to all these people for their generosity and kindness.

CHAPTER 1

History of Contests

Contests and competitions have been a part of the history of photography since its beginnings. In the late nineteenth century, contests often ended in great exhibitions that awarded impressive medals and certificates. Some of these early contests were sponsored by film and camera manufacturers; others by regional, national, and international photographic societies.

The photography competition was often a part of an art show, fair, or international exposition. It frequently followed the format of a juried show, where a panel of jurors prescreens the entries to choose the contents of a show; the judges then choose the winners from the entries in the show. This tradition was adopted from the allied art of painting, with the judging done by a panel of recognized photographers. The certificates, medals, and other awards would be prominently displayed in the studios of the winning photographers and used by them in advertisements for their services. For instance, Mathew Brady's business cards stated that he had been awarded prize medals at the 1851 World's Fair in London and at New York's Crystal Palace in 1853.

In the 1930s, when amateur photography really began to become popular, the number of contests multiplied greatly. Unlike the early competitions, which were held mostly for professional photographers, these later contests were primarily for amateur photographers and students. Most contests held today follow this tradition. They are generally sponsored by local, regional, national, and international organizations, or by magazines, newspapers, photo equipment manufacturers, museums, schools, state fair committees, government offices, camera clubs, and business organizations. For example, as part of the Bicentennial Celebration in 1976, the Kinney Shoe Company sponsored a nationwide "Great American Face" photo contest. This concept was so popular that airlines, cities, and even baseball teams held "Great American Face" days.

Two very important annual contests initiated in the 1940s are still going strong today. One, the Scholastic/Kodak Photogra-

phy Awards Contest, is a national competition for high school students that awards scholarship money to the winners. The other is the "Pictures of the Year" (POY) contest, which is open only to working newspaper and magazine photographers in the United States. Jointly sponsored by the National Press Photographers' Association and the University of Missouri School of Journalism, the POY's purpose is to maintain a high level of work in photojournalism and to reward outstanding and highly talented professionals in this field.

To many contestants, the most desirable prizes in any photo contest are the cash awards, and these may be considerable. A 1971 *Life* magazine contest paid a total of $47,000 in prizes. The present Kodak International Newspaper Snapshot Awards (KINSA) contest, which is open to amateurs in the United States, Canada, and Mexico, pays a total of $55,000 in cash and travel awards. However, other prizes are also substantial. The first *Natural History* magazine contest, in 1968, offered a round-trip to Delhi, India, as the Grand Prize, and two prizes of a 50-volume Naturalist's Library for best in category. Still one of the leading photo contests (see chapter 2), the *Natural History* competition continues to award a trip or cash equivalent for the Grand Prize, but instead of the Naturalist's Library, substantial cash awards are given. Other contests offer similarly desirable awards: expense-paid trips, scholarships, medals, certificates, ribbons, and all kinds of merchandise—automobiles, cameras and other photo equipment, golf carts, sporting goods, books, and much more. An unusual prize, won in the early 1950s, was a set of 24-carat goldplated tableware that the winner is still using today.

CHAPTER 2

Varieties of Contests

There are many different kinds of contests with varying ground rules and procedures. Some are obviously commercial in nature, with the sponsor wishing to publicize a particular product or service; others are held by small organizations simply for the enjoyment or education of their members. There are theme contests, general-interest contests, contests for amateurs, for professionals, for children. Several individual contests, each one representative of a different kind of competition, will be discussed in this chapter.

CONTEST SPONSORS

The photographer should be aware that contests are not held for the sole purpose of rewarding photographers. They are usually conceived as promotional efforts for drawing attention to something that the sponsors want to publicize: products, organizations, ideas, places, events, holidays, social improvement schemes, or publications—to name a few. For example, the annual *Natural History* magazine contest was initiated quite frankly to get attention for the magazine.

TYPES OF CONTESTS

There are several different types of contests, each conceived to satisfy a particular sponsor's needs. Some of their characteristics are described below.

Small-Group Contests. The smaller competitions are generally run by camera clubs or photography schools or classes, or sometimes by individual business firms for their employees and associates. These contests are invaluable as starting points for getting your work seen and for comparing it to the work of others. The members of the

group determine the rules of the contest and the subject-matter of the entries; they decide on the judging criteria, procedures, display of photographs, and judges. The contest is often held as a social function, with entrants, family, and friends present during the judging. There are open discussions about the merits of the entries, and the judges are expected to express how they feel about the work. These contests can be a lot of fun, and are a good way to sharpen contest skills. Most camera clubs have monthly or semiannual contests of this sort and often take part in contests with other clubs.

Exhibition Contests. This type of contest is organized for creating large exhibitions. A first judging panel will choose a number of photographs for exhibition, and from these a second panel will then choose the top winners. There are many art fairs that include photography, and that award prizes and citations to the exhibited work. Entry forms for these contests are generally quite simple.

Private-Organization Contests. These are large contests, usually run by large companies or business or nonprofit organizations for advertising or public relations purposes. The sponsoring organization determines the rules and regulations, which are spelled out on widely distributed printed entry forms and which may be quite complicated and detailed. The judging is generally not done publicly, and only the prizewinning and honorable-mention photographs are announced. These contests usually award cash sums, trips, products, or citations, and often publish or exhibit the winning pictures. It is with this last type of category that this book is mainly concerned.

CONTEST REQUIREMENTS

The interested photographer soon discovers that there are all kinds of contests: international, national, regional, local; those limited to professionals, to students, or to amateurs. Certain contests accept only color photographs, others only black-and-white, others both. Some stipulate the use of only a certain brand or type of equipment, film, or paper; some limit the type of subject matter; others require

that the photograph be taken within a certain time period. Some contests are held regularly, some intermittently, some only once. Some contests only accept photographs that have not been published; others stipulate prior publication as an entrance requirement.

In order to insure the eligibility of your work, it is necessary to read the contest rules and requirements with great care and attention to detail. One stipulation in all contests, which is a legal requirement, is that employees of the sponsoring organization and their families are not eligible (the definition of "family" is, apparently, never clarified, but for most practical purposes it can be taken to mean an employee's children, spouse, siblings, parents, and those individuals' current spouses).

In addition, contests may stipulate the age of the participant, the number of photographs that may or must be submitted, the deadline date, the manner in which photographs must be submitted, the form they may take (transparency, print, size), and, of course, subject matter and even locale. Failure to adhere to any of the requirements is automatic grounds for ineligibility, no matter how good the photograph may be.

Finally, the rules should be read very carefully to find out whether they are fair to the contestant. A number of contests are not entirely fair—either because of the way they are judged, the manner in which the photographs are handled, the eventual disposition of the photographs, or the conditions of the prizes and how they are awarded. This subject will be covered in greater detail elsewhere in the book.

READING THE ENTRY FORMS

Several contests will be examined here to point out some of the areas that should be considered when reading the forms.

Natural History Contest. The accompanying announcement for the *Natural History* magazine contest is a particularly succinct one. This is an annual contest, for which an announcement appears full-page in one of the issues of the magazine, usually at the beginning of the year.

NATURAL HISTORY MAGAZINE CONTEST

This year, the Grand Prize of Natural History's Photographic Competition will be a ticket for the American Museum of Natural History's Discovery Tour through the Aegean and the Middle East. The winner will fly from New York to Athens, from where the tour's cruise ship will sail for Egypt, Israel, Cyprus, and Turkey. The tour will include a three-day excursion to Cairo and Luxor, a two-day trip to Bethlehem and Nazareth, and visits to Jerusalem, Rhodes, and Istanbul. The Grand Prize-winner will have the chance to photograph such magnificent sites as the Temple of Poseidon at Sounion, the church of Saint Sophia, and the Seraglio in the Topkapi Palace Museum, as well as the Aegean's spectacular scenery.

Besides the Grand Prize, the [year] competition offers cash prizes totaling more than $3,000. The winning entries will be published in a special double issue of *Natural History* in August and exhibited at the American Museum of Natural History.

The four categories—broad enough to fit the interests of any photographer—are: (1) The Natural World; (2) A Sequence of an Event in Nature; (3) Photomicrography, including pictures with a scanning electron microscope; and (4) The Human Environment. First prize in each category is $500. In addition, all entries are eligible for the following awards: Humor in Nature, $200; Urban Wildlife, $200; and ten Honorable Mentions at $100 each.

The deadline is [date]. Please put your name and address on every entry and include a stamped, self-addressed envelope—since we do want to return your pictures to you.

To all, the very best luck!

THE RULES

1. The competition is open to everyone except employees of the American Museum of Natural History and their kin.
2. Competitors may submit up to three previously unpublished entries in each of the four categories. Decision of the judges is final.
3. The Museum acquires the right to publish, exhibit, and use for promotion the winning photographs. The Museum assumes no responsibility for other entries.

4. Entries may be transparencies or prints up to 8 by 10 inches, and each must bear the photographer's name and address.
5. Enclose a self-addressed, stamped envelope for the return of entries.
6. Entries must be postmarked no later than [date].
Pack them carefully and mail to:
Natural History Photographic Competition
11 West 77th Street
New York, N.Y. 10024

Everything in this announcement is very clearly spelled out: the prizes, who is eligible, and the number of photographs that may be submitted. Additionally, the announcement describes what kinds of photographs to submit (note that Category 4 is especially broad), size requirements (color or black-and-white is not specified), how photos should be submitted, how to insure return of photographs, deadline dates, and the date the winners will be announced. The announcement also explains that the winning photographs will be published in the magazine and exhibited at the American Museum of Natural History. A point to note is rule 3, which states the uses to which the Museum may put the winning photographs. The implication here is that aside from the special exhibit and the special magazine issue, the photographs may be used elsewhere in Museum literature or exhibitions as the Museum sees fit; however, the Museum does not claim exclusive permission to use the photographs, which means that the photographer may enter them in other contests or even sell them at his or her discretion.

Since it first started in 1968, the *Natural History* contest has drawn entries from all over the world and has been one of the best general contests around. As promised, every year the winning photographs are published in *Natural History* magazine, usually in the July or August issue. They are always beautifully laid out over about 16 pages, with plenty of text material, full credit to the photographers, and information about the judges. Three well-known people in the field of photography (photographers, editors, critics, museum curators, etc.) are chosen each year as judges for this contest. For the judging, the submissions are arranged according to category. The slides are projected on a small screen so that a larger size can give them no advantage over the prints. According to *Natural*

History's art director, the technical level of the entries has been improving each year since the contest was started, but there is no great difference in the ideas.

National Bowling Council Contest. Here is a sample of an announcement for a contest with excellent prizes.

TWO-THOUSAND DOLLARS IN PRIZE MONEY TO BE AWARDED BY NATIONAL BOWLING COUNCIL

WASHINGTON, D.C.—The National Bowling Council today announced the fourth annual Bowling Photo Contest featuring $2,000 in prizes including a $1,000 first prize awarded for the top photograph.

The contest is open to all press photographers on daily and weekly newspapers in the United States as well as free-lance photographers.* *Pictures submitted must be published* and appeared between April 2, 19-- and April 1, 19--.

Along with the $1,000 grand prize, the winner will receive an all expense paid trip to Washington, D.C. Second prize is $500; third prize is $250; and five honorable mentions of $50 each will be awarded.

The winning photos will be judged by a select panel chaired by Kevin Fitzgerald; photo editor of *Sport* magazine.

The winning photos must reflect the excitement, vitality, skill, or recreational benefits of the sport of bowling and will be judged on the basis of human interest, imagination, originality, and creativity.

The official rules are contained in the story, however, one important rule is that the photos must be published (bowling publications excluded) and proof of publication be submitted with the original 8 x 10 photo.

"We certainly hope all photographers across the country will submit an entry this year," commented Council President Woody Woodruff.

WASHINGTON, D.C.—The following are the official rules of the National Bowling Council's Bowling Photo Contest:

—Send your bowling photo along with proof of publication (a press clipping of the photo including name of publication

and date) to: KEITH SATTER c/o National Bowling Council, 1666 K Street NW, Washington, D.C. 20006. Photos must be original and published between April 2, 19-- and April 1, 19--.

—Each entry must be accompanied by your name, address, phone number, and place of business.

—Photos can either be in color or black and white and preferably 8 x 10.

—Submit as many entries as you wish. Eight cash awards include FIRST PRIZE: $1,000; SECOND PRIZE: $500; THIRD PRIZE: $250; and FIVE HONORABLE MENTIONS AT $50 each. First prize winner will receive an all-expense paid trip to the National Bowling Council headquarters in Washington, D.C. to receive his award.

—The contest begins April 2, 19-- and ends April 1, 19--.

—The eight winners will be announced by May 15, 19--.

—All bowling photos will be judged on the basis of human interest, imagination, and creative ingenuity, by the National Bowling Council. All photos and press clippings become property of the National Bowling Council.

—The contest is open to press photographers (bowling publications excluded from entering) and free-lance photographers only in the U.S.A. and excludes members of the National Bowling Council, their employes and agencies.

This contest, sponsored by the National Bowling Council, accepts only photographs that have already been published, and that illustrate a very specific subject. This contest is primarily for working newspaper photographers, either staff or freelance. Note however, that regular employment by a newspaper is not required, nor is it stated that the photograph must have been sold for cash or any other consideration. Finally, the definition of "daily and weekly newspapers" is fairly broad, and might presumably refer to house organs or weekly "mailbox stuffers" published primarily for the benefit of local advertisers. In other words, if your photograph has been published by any daily or weekly newspaper in the United States, and if it relates to bowling, it is eligible for this contest.

New York **Magazine Photo Contest.** *New York* magazine, a weekly publication dedicated to general interest news about New York City, ran a one-time contest in 1979 called "New York Through a

Window." The full-page announcement, including an entry blank, appeared in the June 4, 1979, issue of the magazine, and posters were placed in museums, schools, and stores around the city.

ANNOUNCING THE NEW YORK PHOTO CONTEST: NEW YORK THROUGH A WINDOW

This most photogenic of cities can be photographed in an infinite number of ways. We propose, therefore, a slight narrowing of focus. Contestants (no distinction will be made between amateurs and professionals) are invited to submit pictures taken from a window—home, office, public building, *any* window in the five boroughs. Clearly the inspiration for this theme is Ruth Orkin's magnificent series taken from her window overlooking Central Park. Ms. Orkin is one of the judges; the others are Truman Capote; *New York*'s art critic, John Ashbery; *New York*'s design director, J.-C. Suarès; and the photographer and filmmaker Gordon Parks. Photographs must have been made this year, and no more than five may be submitted by any one contestant.

All photographs will be judged solely on artistic merit.

The decision of the judges will be final. Entries must be received by July 9, 1979. Winners will be notified by mail and announced in the issue of August 20, 1979.

PRIZES

First prize..$1,000
Second prize... $500
Third prize... $250

Fifteen honorable mentions, each of which will be given a copy of Ms. Orkin's book, *A World Through My Window*. Any applicable taxes are the sole responsibility of winners.

RULES FOR SUBMITTING PHOTOGRAPHS

Photographs may be in any combination of color and black-and-white. Size of prints may not exceed eleven by fourteen inches. Color photographs may be prints or transparencies. Each print or transparency must be labeled with your name, address, and phone number. All 35 mm. color slides must be submitted in see-through mounts with multiple compartments. Larger color sizes should be placed in single transparent holders.

Photographs must be submitted in a manila envelope containing a self-addressed stamped manila envelope and card-

board backing. Include the completed entry form on this page, or a piece of paper with the same information. No purchase is required.

Your photographs may be held for some time beyond the closing date of the contest, although an effort will be made to speedily return those submissions not being held for final judging. Not *New York* Magazine, nor the New York Magazine Company, Inc., nor its employees, agents, or officers will be responsible or liable in any way for any loss or damage to contestants' photographs. Winning contestants may be asked to supply a release for publication for recognizable individuals appearing in their photographs. It should be understood by contestants that although they will own their photographs, *New York* Magazine shall have the right to publish any and all prizewinning pictures in the magazine and in advertising and promotion relating to the competition. Employees of the New York Magazine Company, Inc., and their families are not eligible. This competition is subject to all local, state, and federal regulations.

Send your pictures to:
NEW YORK MAGAZINE PHOTOGRAPHY CONTEST
755 Second Avenue, New York, New York 10017
Complete the following (PLEASE PRINT):
Name_____
Address_____
City_____State_____Zip_____
Number of color entries:_____
Number of black-and-white entries:_____
Total number of entries:_____
I have read and agree to the rules of the *New York* Magazine Photography Contest.
Signature_____Date_____

This is a one-time contest inspired, as the form notes, by a series of photographs by Ruth Orkin, some of which had been published in an earlier issue of the magazine. The entry form itself is an excellent example of its kind. The rules and regulations are full and explicit. Nothing is left for guesswork or assumption. It includes information on deadline date for submissions; number, size, type, format, and presentation of photographs; names of judges and judging criteria; when and how winners will be notified, and spe-

cific descriptions of prizes. The required subject-matter of the photographs is clearly explained, and a specific time limit is given within which the photographs must have been taken. Finally, the form is very precise concerning use and ownership of the prize-winning photographs.

The judges for this contest were chosen because they represented a great diversity of opinion and taste, and it was the desire of the sponsors that the winning photographs represent a diversity of styles and techniques.

Although the *New York* Magazine contest was open to both professionals and amateurs, and although New York City certainly has plenty of professional photographers, only one of the top prizes was won by a professional, who split first prize with a physician. The second prize was split between a schoolteacher and an architect, and the third prize was won by a graphic designer. Although the contest was open to both black-and-white and color photographs, all the top prizes were for color; and of the 15 honorable mentions, only 3 were for black-and-white. As promised in the entry form, the winning photographs were published in the August 20, 1979, issue of the magazine.

Pictures of the Year Contest. Since its inception in 1942, one of the most prestigious photography contests in the United States has been the annual "Pictures of the Year" competition, generally referred to as the POY. Sponsored jointly by the University of Missouri School of Journalism, the National Press Photographers' Association, and Nikon, Inc., the POY sets the highest standards for photojournalism. It is restricted to photographers working on newspapers and magazines, with a special section for photographers in the United States Armed Services. Highest honors go to the Newspaper Photographer of the Year, the Magazine Photographer of the Year, the Military Photographer of the Year, and the winner of the Nikon World Understanding Award. These four top winners each get $1,000 and a Nikon camera.

Although eligibility for this contest may be limited, a reading of the contest entry form and the definitions of the different categories may help give all photographers an understanding and insight into what good photography can—or should—be about.

The Nikon World Understanding Award was established to recognize and honor a living photographer whose work best portrays the common purposes of mankind. To describe what the judges seek, the entry form makes the following comments on concepts all photographers should consider:

> Photography has the unique ability to cross language and racial barriers to help us understand each other. As Edward Steichen said, ". . . the art of photography is a dynamic process of giving form to ideas and of explaining man to man." The award was established to recognize and honor a photographer whose work best portrays the common purposes of mankind. Submissions may show facets of human relations, friendship, mutual concern for the environment, a lifting of hope for peace, or an aspect of life appropriate to the theme of world understanding.

Another generally valuable and helpful excerpt from the POY entry form defines the thirteen categories of newspaper submissions:

NEWSPAPER CATEGORIES

1. Spot News—a picture of an unscheduled event for which no advance planning was possible.
2. General news or documentary—a picture of a scheduled or organized event for which advance planning was possible.
3. Feature picture—usually a "found" situation that has strong human interest—a fresh view of the commonplace.
4. Sports action—a picture that portrays participation in the game or sports event.
5. Sports feature—a feature picture that is sports related.
6. Portrait-Personality—a picture that captures an aspect of the subject's character.
7. Pictorial—a picture that exploits the graphic aesthetic qualities of the subject with emphasis on composition.
8. Editorial Illustration—a nonreportorial picture produced from a preconceived idea and intended to clarify or dramatize nonvisual concepts.
9. Food illustration—single picture.
10. Fashion illustration—single picture.

*11. News picture story—maybe spot news or general news.
*12. Feature picture story.
*13. Sports picture story.

*The pictures should be edited to reveal a story line or point of view and should be arranged in a layout that helps communicate their message.

The judging for the POY, which lasts for three-and-a-half days, is done each year by five people chosen both for their reputations in the field and for their divergent opinions and varying geographical biases. The judging procedures are very carefully organized and the manner in which the photographs are presented has been given much consideration—the lighting, for example, is constantly improved upon. The submissions are viewed according to category, and each judge looks at everything. The votes are recorded electronically.

The results of each annual contest are published in a handsome book entitled *The Best of Photojournalism* and are shown in a touring exhibit throughout the country.

Since the POY is one of the most important photo contests, it will be referred to frequently throughout this book. For further information, write to: Angus McDongall, POY Contest Director, University of Missouri School of Journalism, 100 Mary Hall, Columbia, Missouri 65211.

The point of this chapter has been to show that there is a wide variety of photo contests going on throughout the country. Rules and eligibility may differ greatly, and obviously each contest announcement must be read carefully. You may decide that you do not have the kind of material that is suitable for the contest, or that you are not eligible, or even that you are not interested in the kind of awards that are being offered. On the other hand, there are undoubtedly a number of contests given every year that may suit your own requirements perfectly. The following chapter will provide information on where and how to locate the contest or contests that are right for you.

CHAPTER 3

Finding Contests

As a potential contest entrant, the most important point to remember is that contest sponsors are as interested in finding you as you are in finding contests. Consequently, they will try to reach you through a variety of media: newspapers, magazines, schools, museums, galleries, camera clubs, photo stores, even radio. The photography magazines are a very good source for uncovering news about contests, and notices of contests also appear in other kinds of magazines: national, regional, special-interest, and trade publications.

Obviously, it is impossible for the average contest entrant to subscribe to or otherwise be in contact with the myriad sources of information on photo contests without becoming totally inundated in a sea of paper. Happily, there are several excellent sources of digested material.

PHOTO INSIGHT

One of the best sources around for news about photo contests is the newsletter *Photo Insight/Photo Contest News* (address: 169-15 Jamaica Avenue, Jamaica, New York 11432). *Photo Insight,* which is published every other month, is specifically dedicated to listing announcements of photo contests. It was started in 1975 by Conrad Lovelo, Jr., who enjoyed entering photo contests and found that there was no central source for finding out about current ones.

Lovelo's newsletter lists all kinds of competitions—local, regional, national and international. In addition to the contest information, other valuable and interesting features of *Photo Insight* include photographs by readers; news of museum shows, exhibits, photo workshops, art fairs, and exhibitions that are seeking photographs; and articles by professionals in the field. Every issue has at least one complete announcement with the entry blank, which enables the readers to submit their entries directly rather than writing first to the sponsor for the entry forms and rules and regulations.

The information in *Photo Insight* is well organized and very well presented. For each contest featured, all available pertinent information is listed: what kind of photographs are being sought, eligibility, awards, and where to write for more information. An example is this description of a small, local, one-time contest.

KNOTT'S PICTURE YOUR KID PHOTO CONTEST

Closes: [Date]

Fee: None

Open to photos of children made at Knott's Berry Farm

Limit: 4 photographs; color slides, color prints or monochrome prints.

Theme: This contest is for photographs of children being children and somewhere in the background must be a recognizable part of Knott's Berry Farm.

Prizes: 1st Prize - Nikon Photographic Equipment for a family of five, to include a Nikon FM Camera, with a 50mm F2 lens and MD-11 motor drive unit, a Nikon EL2 Camera equipped with AW-1 auto winder, a 28mm and 85mm lens, a pair of 8x24 Nikon binoculars and a Nikon R-10 super zoom movie camera. Plus other prizes to a total of $7,500.00.

ENTRY FORMS: Knott's Berry Farm
c/o Promotions - P.I.
8039 Beach Boulevard
Buena Park, CA 90620
(714) 827-1776

An added feature of *Photo Insight* is the editorial comment that may appear following the contest description, as in this example:

DIVISION: Prints; Black and white or color

SIZE: 11x14

AWARDS: Ribbons and Certificates

RULES:

1. All entires must be mounted
2. Name, address and telephone number must be on back of mount in upper right hand side.
3. All entries become the property of the State Park Commission.

MAIL TO: BARBARA CONNOR
State Park and Recreation
Commission for the City of N.Y.
1700 Broadway
New York, N.Y. 10017

EDITORS NOTE: This contest cannot be recommended because of rule number 3. Ms. Connor feels this contest is a worthy venture since the photographs will tour the underprivileged areas of New York. Ms. Connor also vows to change rules and prizes in next year's contest.

Also listed in *Photo Insight* are large, international competitions such as the entry below. This is a very broadly based contest, as should be apparent from the list of categories. This particular competition is held annually; you might want to write to the address given on the form for information on current rules and regulations.

WORK AND LEISURE INTERNATIONAL PHOTO CONTEST [year]

Closes: All entries must be postmarked no later than [date] and must bear the words WORK and LEISURE; (overseas entries by air mail). Entries should be in sealed envelopes, correctly stamped.

CATEGORIES:

A) WORK
A fundamental value of human life and a basic human right.
1) Work producing energy (waterwork, mining, reactor)
2) Work making products (Industry, production, skilled trades)
3) Work handling goods (Trade, distribution, transport)
4) Work connected with natural resources (Agriculture, fishery, forestry)
5) Work providing services (communications, restaurant, adminis.)
6) Work on construction projects (Bridges, roads, buildings)
7) Work of a creative kind (fashion, arts & crafts, design)
8) Work on an artistic nature (fine & pictorial art, music)

9) Work in scientific fields (research, medicine, technology)
10) Work of an educational nature (school, teaching, vocational training)
11) Work in social professions (caring for the sick and aged, youth welfare
12) Work of a special character (migrant workers, work of disabled persons, forced labor)

and

B] LEISURE

Quality of life and self fulfillment for all through the creative use of free time.

1) Physical leisure (All sports, walking, tours, gardening)
2) Intellectual leisure (Reading, table games, museums)
4) Artistic leisure (do it yourself, handicrafts, music)
4) Spiritual leisure (meditation, rituals, yoga)
5) Learning leisure (evening school, courses, discussion)
6) Holiday leisure (excursions, explorations, travel)
7) Social leisure (nursing, care, charity)
8) Leisure for the aged and handicapped (games, performance, gatherings)
9) The absence of leisure (loneliness, boredom)
10) Wasted leisure (Non respect of the human environment)

But also

C] UNEMPLOYMENT

Forced leisure - the loss of a basic human right.

RULES

Everyone can enter the contest regardless of age, whether a professional or amateur, as an individual or a group. Every photo entered must bear the name, address, country, age and profession of the photographer on the back, also the title chosen and the appropriate category. (e.g. "Keep Fit While Rambling").

ENTRIES;

Black and white and or colour prints will be accepted.
The following entries may be made:
—up to six separate photos and/or
—up to three series of photos each consisting of not more than six prints.
Connecting features should be apparent from the series of photos.

Permitted print sizes are:
18x18cm-18x24cm-24x24cm-24x30cm-30x30cm Transparencies will not be judged.

JURY:

Entries will be judged by well known experts in the photographic and thematic fields. The juries decisions are final.

PRIZES AND AWARDS:

The best photos from the contest will be shown in the WORK and LEISURE display among the Photokina photographic exhibitions of Cologne from September 15 to October 1, [year]. United Nations plaquettes, photokina obelisks and FIAP medals will be awarded for the most outstanding entries. In addition, Lufthansa Airlines will grant international flights as prizes, thus contributing to world wide encounters and providing support for the work and principles of the organizations involved. Every participant whose work is shown in the WORK and LEISURE exhibition will receive a photokina United Nations certificate.

CONDITIONS

By entering the contest, the photographers confirm that they themselves have taken the photos submitted and own all rights connected with them. If so required they also agree to loan, without charge, the original negatives or transparencies of their entries to photokina to allow enlargements and press photos to be made and for possible publication in the photokina catalogue. The utmost care will be exercised when handling and returning the original negative or transparency but no liability for loss or damage can be accepted. All entries after judging will be deposited in Geneva with the United Nations. In the event of later publication the relevent photographers will be contacted and offered a suitable fee. Photos shown at photokina will be kept for achievement purposes with the agreement of the photographers. The photographer retains the copyright.

ADDRESS FOR ENTRIES:

WORK and LEISURE
PHOTOKINA-BURO
P.O.B. 21 07 60
D 5000KOLN 21 GERMANY

GADNEY'S GUIDE

Another excellent source for finding out about photo contests is a publication called *Gadney's Guide to Contests, Festivals, and Grants.* This 578-page book contains 140 pages of information on photography contests alone, in addition to related information on still photography, film, video, and scriptwriting. Alan Gadney, who compiled this reference work, is a filmmaker and writer who used the contest pathway to a professional career.

To give some idea of the scope of the information contained in *Gadney's Guide,* here are the listings under "Photography" in the table of contents.

PHOTOGRAPHY

Arts & Crafts Fairs/Festivals (in U.S.)
Exhibitions/Galleries
Grants/Scholarships/Loans
Nature/Animal/Wildlife
Photo Shoots (California)
Photography
Photography (Regional/State)
Photojournalism
Prints (Monochrome/Color) (in U.S.)
Prints (Monochrome/Color) (Regional/State)
Prints & Slides (Monochrome Color) (in U.S.)
Prints & Slides (Monochrome/Color) (Foreign)
Prints & Slides (Monochrome/Color/Nature) (in U.S.)
Prints & Slides (Monochrome/Colors/Nature) (Foreign)
Prints & Slides (Monochrome/Color/Nature/Journalism)
Prints & Slides (Monochrome/Color/Nature/Journalism/Travel)
Professional
Scientific/Industrial
Slides (Color) (in U.S.)
Slides (Color) (Foreign)
Slides (Color/Nature)
Slides (Color/Nature/Journalism/Travel)
Slide Show/Diaporama
Sports

Stereo Slides
Student/Youth/Young Adult
Themes (Various each year)
Travel
Underwater
Of Women
Other

Gadney's Guide is available in the reference sections of most public libraries. For additional information on how to get a copy or where to find it in your area, write to: Festival Publications, 130 South Adams Street, Suite 16, Glendale, CA 91205.

READER'S GUIDE TO PERIODICAL LITERATURE

A third source of information about photography contests is one that may be easily overlooked. This is the *Reader's Guide to Periodical Literature*, a monthly publication with a year-end annual that lists articles appearing in newspapers, magzaines, and journals under a subject index. The *Reader's Guide* is available at any public library. Contest news is listed under the classification "Photography—Competitions." A random selection, from the *Reader's Guide* annual for March 1978–February 1979, shows the following:

Competitions

Best photojournalism of 1977; Pictures of the Year contest and the White House News Photographers Association competition. J. G. Morris. il Pop Phot 83:244+ Ag '78
Club close-ups. E. Rabellino. il Peter Phot Mag 7:36 N '78
Gallery '78. See issues of Petersen's photographic magazine
Prizewinners of the 1977 photographic competition; Oceans. il Oceans 11:41-6 My '78
Showstoppers! National wildlife's annual photo contest. il Nat Wildlife 16:20-31 Ap '78
Winners! first Ms Photography Contest. il Ms 7:70-1 D '78
Winners of the 1978 Natural History Photographic Competition. il Natur Hist 87:98-115 Ag '78
See also
Scholastic Magazine Awards

Although this listing only gives news of past competitions and results, information is provided about five regular annual contests: the POY, *Oceans* magazine, *National Wildlife* magazine, *Natural History* magazine, and the *Scholastic* magazine awards. Other contests, which may or may not be held on a regular basis (it is not entirely clear from the listings in the Reader's Guide alone), are also listed. Further research in the publications cited in this listing will clarify this point, and also illustrate what kinds of photographs were prizewinners. Note also that if a periodical runs an article *announcing* a contest (advertisements are not considered articles), this article will also be listed in the *Reader's Guide.*

OTHER SOURCES OF CONTEST INFORMATION

In addition to the three publications listed above, photo contest announcements may appear almost anywhere. The photography magazines are an obvious source of such information. Camera clubs and photographic societies frequently receive contest literature, as do photo stores, schools, and museums and galleries.

A publication called *Photo Weekly* (address: 1515 Broadway, New York, New York 10036), which is distributed to retailers, carries all kinds of photographic news, including items about contests, that may or may not reach the general public. For example, through *Photo Weekly,* a young photographer found out about a contest sponsored jointly by the Chamber of Commerce of a small city near where he lived, and a local color film processing laboratory. He entered the contest and won. The prizewinning photographs brought a small cash award ($30) and were also very nicely exhibited in the City Hall. A larger contest featured in *Photo Weekly* (among other publications) was one sponsored jointly by the Professional Photographers of America and the Eastman Kodak Company. The contest, "Decorating with Photographic Art Wall Design," included prizes for interior designers as well as for photographers.

Do not overlook less likely possibilities. A trade publication for actors carried news of a contest for photographs taken in Tucson, Arizona, and of another contest sponsored by Nikon Inter-

national. Since you can't read everything yourself, ask friends and acquaintances to keep their eyes open for contest news in the periodicals they read. Sooner or later, something will come along that is just what you are looking for.

Individual Sources of Photo Contests. Several photographic organizations run frequent contests.

The Photographic Society of America (PSA) conducts many contests. Their information booklet is available from: 2005 Walnut Street, Philadelphia, PA 19103.

The Professional Photographers of America (PPA) is another organization that has juried shows and contests. Their information booklet is available from: 1090 Executive Way, Des Plaines, IL 60018.

Mr. Gordon Johnson, of the American Foundation for Photographic Art, Ltd., can provide information about a contest conducted by that organization. Write to him at: P.O. Box 29, Woodstock, VA 22664.

Contests for Young People. Several organizations for young people run contests for their members, aged 6–15. Both Boy Scouts and Girl Scouts of America run local, regional, and national photo contests, with prizes varying from certificates to $1,000 U.S. Savings Bonds. For information write to: The Scout Photo Scholarship Awards, Boy Scouts of America, P.O. Box 61030, Dallas/Ft. Worth Airport, TX 75261; or to Girl Scout Photography Awards, Girl Scouts USA, 830 Third Avenue, New York, NY 10022.

Boys' Clubs of America have an active National Photography Program to encourage members to become acquainted with photography and to take part in their National Photography Contests. Girls are also eligible to participate in these programs. For information, write to: Boys' Clubs of America, Photo Contests, 771 First Avenue, New York, NY 10017.

CHAPTER 4

Contest Details and Cautions

In chapter 2 we presented several contest entry forms to give you a general idea of what contests are like. Now let us take a closer look at some contest requirements. It is important to analyze the rules and regulations quite carefully in order to see exactly what each contest is about. A thorough examination and understanding of all the details will give you a better chance of winning, as well as a better idea of what you can expect as a winner.

ELIGIBILITY

The first thing to determine when deciding to enter a contest is whether you and your photographs are eligible. This can be determined by a careful reading of the requirements listed in the contest rules.

Age Requirements. In terms of the photographer's eligibility, several factors may be important. Some contests have age requirements or, more frequently and specifically, education-group limitations—for example, a contest may be limited to high school students, college students, fifth-, sixth-, and seventh-graders, and so forth.

Amateur or Professional? Another requirement usually has to do with whether the photographer is an amateur or a professional; some contests are limited to one or the other group. The fact that you have sold several photographs does not classify you as a professional; the general definition of "professional" photographer is an individual who earns most of his or her income from taking and selling photographs. A photo lab technician, editor of photographic books, or a magazine art director is not a professional photographer. On the other hand, a medical photographer submitting photographs of a nonmedical nature might or might not be considered

a professional for the purposes of a specific contest. In situations such as this, it is best for the individual to inquire directly concerning his or her status.

Subject Matter, Place, and Time. As you will learn from the interviews with some contest judges in the following chapter, the first criterion they consider is adherence of picture content to the guidelines stated in the contest rules. Obviously, some contests limit subject matter more closely than others. For example, *New York* magazine's "New York Through a Window" contest would be considerably more limiting in the scope of acceptable photographs than the *Natural History* magazine contest (entry forms for both of these may be found elsewhere in this book).

Closely related to the criterion of subject matter are the factors of locale and time. Some contests stipulate that the photographs must be taken in a specific locale—a state, a city, even a particular neighborhood, park, or other small area. Obviously, this means that the locale must be recognizable: landmarks, typical architecture or topography, type of vegetation are all clues to a specific locale. Time may also be an element in a contest's rules, for example, the "New York Through a Window" contest stiupulated that the photographs must have been made the year the contest took place. In may cases, this element of time may be difficult to prove; however, bear in mind that fashions in clothing, hairstyles, and automobiles change rapidly, and that landscapes and cityscapes alike undergo frequent alterations. An anachronism that you overlook may cause an outdated photograph to be quickly eliminated by a sharp-eyed judge.

Size, Color or Black-and-White, Prints or Transparencies. Most contests stipulate whether they want color only, black-and-white only, or either; if no specifications are given, you may assume that either is acceptable. Some contests do not have separate categories for color and black-and-white; each individual photograph is judged on its own merits. While this "either/or" situation represents a commendable show of openmindedness on the part of the judges, the fact remains that prejudices in favor of one or the other type of photography do exist. It is also true that the element of color

often has a way of catching the eye and imagination in a way that black-and-white does not, and in a choice between two photographs, the black-and-white will have to be extraordinary whereas the color need be merely excellent.

Most contests accept either prints or transparencies. Print sizes are usually limited to 11 x 14 or smaller; transparencies are generally acceptable in any size from 35 mm to 8 x 10 read the rules carefully for exceptions, however). Contest regulations usually give very specific instructions on how transparencies should be presented. Prints should always be mounted, unless the rules specifically request unmounted prints; mounting gives a more finished appearance and provides some protection against damage. It should go without saying that prints should be of the very highest quality possible, whether from black-and-white negative, color negative, or color transparency originals. If you cannot do your own printing, have it done on the outside, preferably by a lab that specializes in custom work. This is expensive, but if you really think you have a prizewinning photograph, the cost is worth it. If you are submitting transparencies, resign yourself to sending originals and hope for the best; but before you do, read the contest's statement concerning return of photographs.

Published or Unpublished Work. Certain contests may stipulate that a photograph be previously published before it is accepted for competition. In this instance, proof of publication must be submitted with the photograph. This will usually consist of a tear-sheet from the publication in which the photograph appeared. A good photocopy of the tear-sheet is generally acceptable providing the photograph is recognizable.

Read the contest instructions carefully to be certain that the publication in which the photograph appeared meets the requirements of the contest. A photograph published in a book or magazine is not likely to be eligible for a contest that stipulates newspaper publication: similarly, if the contest rules require that the publication in which the photograph appeared be a weekly, for example, a photograph published in a daily or monthly publication would not be acceptable.

Releases. Sponsors who intend to publish prizewinning photographs generally require so-called "model releases." A model release is a form which must be signed by any individual whose face is recognizable in a photograph, giving the photographer and whoever else uses the photograph permission to publish his or her picture. If the model is a minor, the form must be signed by a parent or legal guardian. Because of recent court rulings on doctrines of "invasion of privacy," it may sometimes be advisable to obtain releases from the owners of certain inanimate objects, such as a private home. Standard release forms are available at camera stores:

You may feel awkward when you first start asking people for releases. Alva L. Dorn, an experienced photographer and writer, advises his students not to ask for releases when taking the pictures, as this can interfere with the photography. A more tactful method, he suggests, is to offer to send a print to any of the subjects appearing in photographs that may have contest potential. This will suffice to obtain names and addresses; later, if the photograph is submitted to a contest, getting a release should be quite simple.

Dorn tells a story of a photographer who photographed a woman in South America, but who did not think to even get the woman's name. The photograph was subsequently submitted to a contest and won. However, the contest's sponsor required a release. Luckily, the photographer's sister was still in South America: she succeeded in tracking down the woman in the photograph and obtained a release. However, this kind of luck can only happen once. Getting releases is good training; professional photographers have to do it all the time.

PRIZES

Contests offer a tremendous variety of awards and prizes. These may be in the form of cash, trips, equipment (photographic and otherwise), certificates or plaques, or scholarships; in addition, winning photographers may be published or exhibited in galleries, museums, office buildings, and elsewhere.

Before you enter the contest, be certain the prizes interest you. You may not be interested in a scholarship to the college of

your choice or in any of the goods and merchandise offered. Remember that any prize that has a specific cash value (cash itself, a trip, or merchandise), is considered to be taxable income, and you are liable for taxes on the retail value of that item. The exception to this rule is a scholarship award if it is used to get a degree. (Incidentally, *if you win* a prize having a cash value, your costs incurred for entering the contest—entrance fees, printing, postage, etc.—are tax deductible.)

Goods and Services. Read the information on prizes very carefully. If a trip or merchandise is offered as a prize, does the sponsor offer a cash equivalent? (Do not be surprised if the cash equivalent is less than you may think it worth; most suppliers of goods and services provide these for public relations purposes, and their cost evaluations do not include the margin of profit that the ordinary consumer would pay. In other words, if you took the cash equivalent of a camera and lens, you would be given a sum equal to the dealer's own cost rather than to the retail price.) If the prize is a trip, are all expenses paid, including your transportation from and to your home to the points of departure and return? Depending on where you live, the cost of getting to and from these points may be considerable, and other out-of-pocket expenses may also mount up.

Check whether the information on distribution of prizes is specific. The following example, taken from an actual contest form, contains some ambiguities:

> A total of $1,000 in U.S. Savings Bonds will be awarded to winners. Photographers taking the best amateur photo and best professional photo will each receive a $200 U.S. Savings Bond. Other winners will receive bonds of various denominations.

In this example, the sponsors do not give a detailed breakdown of the prize money. Also, there is no information on how many other winners there will be.

Other prize information can also be ambiguous. For example, one contest offered a "fabulous Nikon FM" as a prize. What they did not mention was that the prize was a camera body only,

without a lens. While the camera body itself certainly has a value, it is useless without a compatible lens. To make the prize worthwhile, the winner would either have to buy a lens or try to sell the body, which is now technically "used" equipment and worth less than a similar piece purchased new from a store. You should be aware that contest sponsors are interested in making their prizes seem as valuable as possible; if a lens had been included with the body, it would have been mentioned. You must learn to read between the lines. On the other hand, certain omissions may be merely oversights on the part of the persons writing the form. If the sponsor is reputable and the contest well established, you may decide to take your chances.

Certificates of Merit. Certificates of merit or honorable mentions are often awarded for photographs that the judges consider worthy of recognition although not of prizewinning quality. Such recognition from a reputable contest is certainly an honor, especially if these are not awarded overabundantly or indiscriminately. The Kodak International Newspaper Snapshots Awards (KINSA) gives certificates of merit to all semifinalists; however, KINSA is a huge contest divided into two major segments and the semifinalists have already passed through several preliminary stages of judging to reach that point. Other contests will specifically state the number of certificates of merit to be awarded, and if you have some idea of the size of the contest you should be able to judge the value of the award.

There are certain contests, however, which state simply that an undetermined number of certificates of merit will be awarded at the discretion of the judges. This can be a very tricky issue. First, the value of such a distinction may come under question; the judges may give certificates of merit to anyone willing to pay the postage and admission fees. An even more serious problem may arise in instances where the sponsors claim ownership or at least indiscriminate permission to use all winning photographs (a topic which will be discussed in greater depth later). The recipient of a certificate of merit is just as much a "winner" as the photographer who took first prize. While the top prizewinners may be willing to relinquish certain of their claims in consideration of a valuable award, the winner

of a certificate of merit (which may be of dubious value) gives up his or her rights for nothing more than a piece of paper.

RETURN OF PHOTOGRAPHS

Ideally, the contest sponsors should make some provision for the return of all non-winning photographs as quickly as possible. Many sponsors do provide explicit information on this subject; in such cases, return postage and often return packaging is almost always required—certainly a reasonable request. Since you may be submitting original transparencies or expensive color prints, you should make every effort to comply with the sponsor's requests concerning return material. This includes making absolutely certain that every item you submit is indelibly labeled with your full name and address. While most reputable sponsors make every effort to return eliminated material as quickly and efficiently as possible, some pieces may get mislaid or returned to the wrong person. Unless your work is carefully labeled, you have no recourse if something gets lost.

Send your photographs by registered mail with return receipt requested; this will at least give you some proof that your material has been received by the sponsor. Postal insurance will only pay for lost negatives, so insurance may not be worthwhile. You may include return postage to cover the same kind of handling, but it is up to the sponsor to have this package registered and this may or may not be feasible. Unfortunately, there is no way to ensure absolutely the safety of your material. Also, before you mail anything, make a record for yourself of what you are sending.

Certain contests do not return photographs. The seriousness of this breach may depend upon the reason and the sponsor's credibility.

On the other hand, there are certain contests where refusal by the sponsor to return nonprizewinning photographs can be quite a danger signal. A contest run by Photo Talent Associates, a photo stock house, included the following under its list of rules:

6. All prints and slides will be returned if accompanied by necessary return postage, except those selected for PTA stock library.

7. Each entrant agrees that any print or slide entered may be accepted by PTA for inclusion in stock library; to accept fees negotiated by PTA for use; and to permit PTA to charge its normal agent's commission on fees received.

What the sponsor was claiming was permission to use not only prizewinning photographs, but any photograph entered in the contest that it thought might be saleable. In other words, it was obtaining, without any real contractual agreement with the photographers, a number of photographs for its collection. Neither the exact amount of the agent's fee nor the specific uses of the photograph—both of which would be stipulated in considerable detail in a regular contract—are stated. Aside from the somewhat dubious possibility of having a photograph purchased and published somewhere conceivably without even a credit line), the photographer derives very little advantage from such an arrangement.

USE OF PHOTOS

Since contest sponsors generally go to a considerable amount of trouble and expense to run a photo contest, it stands to reason that they expect something for their troubles beside the opportunity to hand out prizes. Of course, the contest's advertisement itself draws attention to the sponsor and creates a certain amount of good public relations. However, most contest sponsors want a little bit more. Whether what they want is reasonable may be something else again.

Almost every contest wants the use of the prizewinning photographs. This is a reasonable request. For example, *New York* magazine's "New York Through a Window" contest rules state, with admirable clarity, "It should be understood by contestants that although they will own their photographs, *New York* Magazine shall have the right to publish any and all prizewinning pictures in the magazine and in advertising and promotion relating to the competition." The *Natural History* magazine contest's rule is similar, but stated a bit less precisely: "The Museum acquires the right to publish, exhibit, and use for promotion the winning photographs." Here, then, use of the photographs will not be strictly limited to the

contest itself, but it is limited enough. Another reasonable approach is that taken by the sponsors of the Work and Leisure International Contest:

> If so required [the photographers] ... agree to loan, without charge, the original negatives or transparencies of their entries ... to allow enlargements and press photos to be made and for possible publication in the *photokina* catalogue. The utmost care will be exercised when handling and returning the original negative or transparency but no liability for loss or damage can be accepted. All entries after judging will be deposited in Geneva with the United Nations. In the event of later publication the relevant photographers will be contacted and offered a suitable fee. Photos shown at *photokina* will be kept for achievement purposes with the agreement of the photographers. The photographer retains the copyright.

The question of copyright and ownership of photographs has been a sore point in photo contests for many years. The new United States copyright law, passed in 1978, states that the author (photographer) of an original work owns the copyright unless he or she signs an agreement to the contrary. Transfer of rights must be made in writing, and may be done piecemeal—some rights may be transferred while others are retained. Also, lack of copyright registration does not automatically mean forfeiture of the copyright, although registration is a prerequisite to an infringement suit.

This very brief statement of a few germane points of the new copyright law is intended to illustrate the conflicts that may arise out of certain contest sponsors' claims. For example, the National Bowling Council's contest rules state: "All photos . . . become property of the National Bowling Council." Another set of contest rules, from the American Kennel Club, states: "All winning entries become the property of The American Kennel Club, which acquires the right to publish, exhibit and use them in any manner it so chooses." Other contests have similar statements.

Statements such as these claiming ownership of or all rights to photographs are clearly in contradiction to the copyright law. To begin with, many entrance forms do not even ask contestants to sign waivers agreeing to the rules of the contest. Even if you do sign such

a form, it can hardly be considered a transfer of copyright, no matter what the rules of the contest claim. So you still retain ownership of the photograph, and can legally sell it or enter it in another contest as you please. However, unless you have registered the copyright with the U.S. Copyright Office, you are not protected against copyright infringement, which means that once the contest sponsor has the photograph, it can pretty much do with it as it pleases without fear or successful legal action against it. (Obviously, it cannot resell the photograph, since it does not own it; but it can lend it out wherever it chooses.) On the other hand, if the sponsor accepts a photograph with a registered copyright, it can do nothing with that photograph without your permission in writing stating exactly which rights you assign the sponsor. (If you are eager enough to win to let the sponsor have all rights, you can, of course, assign the sponsor all rights.)

The difficulty of all this is the fact that while you may submit any number of superb photographs, all copyrighted, you can do nothing to force the sponsor to give you a prize. Unfortunately, there are no laws prohibiting discrimination on the basis of copyright ownership. On the other hand, if your photograph is not copyrighted, you have very little control over the sponsor's disposition of it. Even if, for example, the sponsor reassigned rights or sold the photograph outright, and did not pay you a royalty to which you might be entitled, you would have to go to the great expense and trouble of legal action in order to gain satisfaction. So it's a Catch-22 situation, and until laws relating to contests themselves are changed to prohibit sponsors from claiming blanket control, it is something that must be dealt with on an individual basis. You may decide that the sponsor is reputable enough to trust not to get carried away, or that the prizes are too good to turn down, and you enter the contest. Or you avoid such contests completely.

Finally, we must return briefly to a point made earlier regarding contests run by stock photo houses. If you want to place your pictures with a stock house, do so, but make certain that you have a standard contractual agreement spelling out exactly the terms under which your photographs may be sold and precisely how much money you can expect to make on each sale. Do not turn your photographs over to a stock house under condi-

tions such as those cited in the earlier example. Stock houses are in business to make money by selling pictures, and if it's your pictures they are selling, you should be making money in a businesslike way too.

TWO EXPERTS' CAVEATS

Two well-known experts in the field of photography contests were asked to summarize their experiences in terms of what to look out for when entering a contest.

Arthur Rothstein, the photojournalist, who has served as a judge for numerous photo contests, points out several areas of concern:

> 1. A large entrance fee that is beyond a fair handling cost. In such cases, you can surmise that the contest is operated solely to make money for the sponsors.
> 2. The sponsor claims all rights to do whatever it wants with the pictures. Some contests are run by photo stock libraries as a means of enlarging their collections without paying photographers' fees. Stock libraries sell photos to many clients, and if they have all rights to your pictures, you will never know how they are being used. They can be published anywhere in the world, and the library can collect the entire fee. Other sponsors, who are not stock libraries, may be seeking a free source of photos to use in their advertising. While such use runs contrary to copyright law, it may require considerable time and legal fees to rectify.
> 3. Original negatives or original transparencies are required. Again, they may be a stock library looking for free pictures.
> 4. The judges are not announced, or are not identified as bona-fide people in the field, or are unknown. This is not, in itself, a reason to decide not to enter a contest. However, it may be one sign that something is wrong.
> 5. The only address is a Post Office box with no identification of the sponsoring company or organization; or the sponsor is not recognizable. If you are dealing with a reputable sponsor, there is generally little cause for concern.

Warren King, a photography instructor whose students have a great record of winning contests was asked how he determines the

worth of a contest and how to avoid those which are fraudulent or self-serving. He replied:

> We stay away from the type of contest where we feel the students are being exploited; in fact, we will not take part in one well-known contest next year because they have not kept their word in merely giving picture credit to the students on published pictures. They keep all the prints and negatives and the students get nothing in return. We save them over $20,000 annually in photographers' fees. . . . We felt we are doing some good for humanity, but I still feel the students deserve recognition for the time and money spent. This contest may die without us, as we are the main contributor—we'll see.
>
> We do our best to analyze the reasons behind a contest. If they are self-serving, we avoid them. When there is a fee, I leave it to the students to decide if it's worth the gamble. The new copyright law prohibits sponsors from obtaining full rights to winning photos. Students have entered several competitions without hearing one word about the outcome. We discuss this situation at length, but have come to the conclusion that most of these are a gamble. Again, about the copyright law, it takes a lot of time and effort to implement it, and I wonder how many of these students' pictures are being used by picture agencies without one cent going to the photographer. Twice in my career clients broke the copyright law; I sued and won both times, but it was hardly worth the time and effort and the bad feelings that were generated.

DETAILS OF THE KINSA CONTEST

Now that you are familiar with what to look for as well as what to avoid in terms of photography contests, you may be interested to learn how one of the largest and oldest is organized. The Kodak International Newspaper Awards contest (KINSA) has been going on for over 40 years, and is well-established and very reputable. Limited to amateurs only, KINSA is conducted annually through approximately 125 participating daily newspapers in the United States, Canada and Mexico.

The KINSA contest is run in two stages, which gives it a build-up effect. Stage One is run by each participating newspaper in its own locality. Stage Two is the international phase, in which the top winners of each newspaper compete against each other.

Stage One. Each participating newspaper conducts summer contests over a period ranging from a minimum of six weeks to a maximum of thirteen weeks. They run their own contests, according to their own wishes, within a frame work established by Eastman Kodak Company, but the rules can vary a bit from paper to paper. There are only two categories—black-and-white and color.

Prizes are awarded every week by the participating newspapers throughout the duration of their individual contests. Usually, two weekly prizes are awarded, one for black-and-white and one for color, along with several honorable mentions. Some newspapers award four prizes a week. Some give money awards.

Here are the basic rules for Stage One of the KINSA contest. As mentioned above, these rules vary somewhat from paper to paper; however, they may be used as a general guide.

RULES:
1. The KINSA contest is strictly for amateur photographers.
2. Only black-and-white or color pictures taken after [specified date] are eligible.
3. Snapshots may be taken with any make of camera, on any brand of film. No artwork or retouching is permitted on negatives or prints—no composite pictures, multiple exposures, or multiple printing.
4. Any number of pictures may be entered. Contestant's name and address must be clearly written in ink on each print or on the transparency mount. Mail entries to the Amateur Snapshot Contest Editor, care of this newspaper.
5. No pictures will be returned. Contestants must be able to furnish the original negative if requested by the Contest Editor. (This requirement does not apply to color transparencies or instant prints.) The sponsors assume no responsibility for negatives or prints.
6. Contestants are permitted to submit pictures to only one newspaper participating in the Kodak International Newspaper Snapshot Awards.

7. To be eligible for a local grand prize, a contestant must sign a statement that the picture, or another closely similar picture of the same subject or situation, has not and will not be entered by him/her in any contest and will not be offered for publication.
8. IMPORTANT: Be sure you know the names and addresses of any recognizable persons appearing in your picture. This is necessary because, in order for it to be entered in the international judging, you must be able to get the written consent of such person or persons to permit use of the picture for purpose of illustration, advertising, or publication in any manner. [Another term for this written permission, is a release.]

Rule 4 means that you can enter as many pictures as you want, each week. So, if at first you don't win, you get repeated opportunities. At one exhibition of the final prizewinning photographs, several of the winners stated they had done just this. One contestant said that she won in the eighth week.

Please note rule 5 which states that no pictures are returned and that negatives (when they exist) must be available upon request. To return the entries, especially for a series of weekly contests, would overwhelm the office staffs; so be sure you have a duplicate if the picture means a lot to you. Negatives of prizewinning photographs may be requested in order to make top-quality exhibition prints for the annual exhibit of the prizewinning photographs and honorable mentions; these negatives are returned. Observe that the sponsors do not ask for complete and total rights to the pictures—a point that is more valuable to you than retrieving a print.

Since the weekly award-winning pictures, and even some honorable mentions, are often published in the participating newspaper, you have a chance to see your work in print as the contest progresses. At the end of Stage One each newspaper has a final judging of all the weekly prizewinners.

Stage Two. Each participating newspaper submits its final eight top winners—four in the color category and four in the black-and-white category—to Eastman Kodak Company for the international judging by a panel of five judges.

In a recent year, the top ten prizes (five for color, five for black-and-white) were expense-paid holidays for two, or an alternate cash award if the winners could not or did not want to take the trip.

First prize: The winner's choice of a 30-day trip anywhere in the world with $1,000 spending money; or $5,000 in cash.
Second prize: The winner's choice of a 21-day trip anywhere in Europe with $500 spending money; or $4,000 in cash.
Third prize: A 14-day trip to Mexico with $250 spending money; or $2,500 in cash.
Fourth prize: A 7-day trip to Hawaii with $100 spending money; or $800 in cash.
Fifth prize: A 7-day trip to the West Indies with $100 spending money; or $800 cash.

In addition, 10 cash prizes of $500 each and 200 cash prizes of $100 each are awarded. All other second-stage contestants receive certificates of merit.

The KINSA contest has established a top reputation in the contest world. The 220 prizes in the international contest are quite generous and clearly defined. Even though the competition is keen, the rewards are substantial, and certainly worth trying for.

Most of the local KINSA contests open in May of each year. Anyone wishing to participate and lacking information about participating newspapers in their area may obtain information from: Contest Activities Section, Corporate Information Department, Eastman Kodak Company, Rochester, New York 14650.

CHAPTER 5

The Judges Talk

It is always interesting, and often useful, to know what goes on behind the scenes at different kinds of photo contests. In this chapter, several individuals who are frequently judges at photo contests will discuss how they approach a judging session, what they look for when reviewing the entries, and what criteria they use. Their insights and tips should be very helpful to you in your efforts to win at contests.

Arthur Rothstein

Arthur Rothstein started his career as a photographer for the great photography project undertaken by the Department of Agriculture's Farm Security Administration (FSA) in the 1930s. Rothstein was one of a distinguished group of photojournalists whose purpose was to show through photographs the effects of the Great Depression on the nation. The FSA photographs had considerable influence on social and economic legislation and have gone on to become a great national legacy. The images produced in the course of that project have become firmly implanted in the nation's consciousness. The photographs are still published and exhibited time and time again. Rothstein himself went on to become a director of photogtaphy at *Look* magazine, where he worked for many years. He is now photo editor of *Parade* magazine.

Rothstein is often asked to be a judge at photo contests, and the fact that he is both a photographer and a photo editor puts him in a unique position to evaluate photographs. Rothstein enjoys judging contests; he feels contests are "a way of encouraging people to express themselves in the medium, and develop a competency." He continues:

> "I have been looking at photographs for such a long time that I
> can appreciate their importance and value. I can speed read a
> photograph, quickly sense the composition, the content, the sig-

45

nificance of the subject-matter. I look at hundreds of pictures every week.

Every contest is different, so when you're judging, it's all relative. You have to adjust your thinking to the individual contest. I judge not on the basis of what is the greatest picture in the world in an absolute sense, but on the basis of what has been submitted, the nature of the contestants, and the aims of the contests. ... Different contests are designed to perform different functions. Some, to select the best work in a particular group. Others, to encourage a certain type of photography. Some, to promote a particular aspect of culture or achievement of photography. And then, of course, there is another problem: you can only select the best of what is submitted. What a judge must do is to pick out the very best of *what is available.*

I wouldn't judge a Boys' Club of America contest in the same way as an Overseas Press Club contest. In the first, you're dealing with nonprofessionals (I don't like the word 'amateurs' because many are as good as any pro)—kids who are often just learning photography, and many who are underprivileged. You can't compare the work of a Boys' Club participant who is thirteen years old with the greatest professional press photographers in the country.

No matter what kind of contest, I look for pictures that have an impact, an idea, an emotion, a sensation, something that affects me. I've been looking at pictures for forty years, so when a picture affects me, I know it has to be good, because I'm hard to please.

More specifically, Rothstein judges on the basis of five basic points (in no particular order of importance): (1) communication of an *idea*; (2) creative *ability*; (3) *interpretation*; (4) *organization* of materials; and (5) *skill.* In some contests, first prize goes to the picture in which two or three of these five points are strong. In others, Rothstein will give a prize for effort—again, because he chooses the best of what is available in that particular contest.

Asked about some of the common failings in pictures that he has judged, and what might be done about them, he replies:

Those who aren't as skilled tend to make certain mistakes. One, they don't get close enough. They don't realize that with the cam-

era, you have to intrude, have to get in there to get the picture. In other words, there's no sense of composition. Composition is another word for organization—organizing materials in your picture so they make sense. In most cases, there should be one center of interest, an ability to bring the elements of the picture to bear, so they all become self-evident; the ability to get to the point, so the viewer doesn't get confused, and can't see the point of the picture, the point you're trying to make.

Rothstein continues, "An important key to entering contests is that the entrants have an idea of what the sponsors are looking for. The same holds true for the judges. I look for the best submissions, according to the hopes of the sponsors."

Rothstein judges about a dozen contests a year; he has judged the Kodak International Newspaper Snapshot Award (KINSA) contest, the Boy Scouts, the Scholastic/Kodak Scholarship Awards; every year he judges the Boys' Club of America photo contests. He was a judge at the first *Natural History* magazine contest in 1968 and at many since then. "The *Natural History* magazine contest," he says, "attracts a special type of person—scientists, people who travel a lot."

In May 1979, Rothstein was the sole judge at a photo contest held at Brigham Young College in Salt Lake City, Utah. Because there was not much prescreening, he was required to look at approximately a thousand photographs, all in the space of three hours, in order to pick sixty prints for an exhibit. The contest was completely open, and any kind of subject matter was acceptable.

Rothstein's feeling was that if he could choose photographs for the wide interest range of the readers of a magazine like *Parade*, he could do the same for the members of a university. In an effort to encourage young photographers, he tried to get as many people as possible into the show. The maximum number of photographs one person could submit was six. Rothstein found that although some students entered such poor work that it had to be eliminated altogether, some were so good that they were represented in the exhibition by all six of their submissions.

The one-judge contest is rather unusual, Rothstein notes. "Most contests are judged by three people. It's better to have an uneven number in case of a disagreement. Five or more judges," he feels, "are unwieldy."

MONICA CIPNIC

Monica Cipnic, associate picture editor of *Popular Photography* magazine, views a lot of pictures as part of her job; she goes to as many shows as possible and is often a judge at photo contests. "Judges," she says, "must stick to the ground rules." She continues:

> For the New York City Police Department contest, I was one of thirteen judges, an unusually large panel. But with any size panel, decisions are always by consensus, and the judges must be flexible. Small contests that may only have one judge are usually run as social affairs, with refreshments, and with the contestants, friends, and relatives present. Often, at these, the judge is expected to offer critiques and explanations, besides choosing the winning photographs.
>
> I was a judge at a contest that had been advertised in the real estate section of the New York *Times* by the builder of an apartment building on the New Jersey side of the Hudson River. The contest was for the best picture of the view that future residents would have. The prize was $500. One contestant has rented a helicopter, and took a picture that included the building and a reflection of the sunset on the New York City skyline. Besides being an excellent photograph, the judges were so impressed by the lengths this contestant had gone to, that they awarded him the prize.
>
> When judging, I like to take a look through and get a general feeling of the submissions. If the contest is thematic, I look for adherence to the theme. Then I look for originality, composition, print quality, and whether it is interesting to me. I have always found something interesting at any contest I have judged.

Ms. Cipnic was a judge at the National Artists' Alliance contest entitled "American Vision," the first of what is expected to be a yearly event. There were 6,000 entries, including color slides, trans-

parencies and prints, and black-and-white prints. The judging procedures, she remarks, were "different from most other contests, in that there were 12 judges who had the double duty of picking 272 photographs for an exhibit, and then, from this group, choosing the 54 prizewinners, who got cash awards and medals. The judging went on for a week; the judges each spent one day reviewing the work for the first elimination, and then all the judges returned for the final windup judging together. Ms. Cipnic continues:

> For the first time in my experience, in this contest, the color prints came out better than the transparencies or the black-and-whites. It could be that with all the new techniques for doing color processing and printing in home darkrooms, photographers are working much harder at making color prints.
>
> There was also a lot of hand-color work in this contest. although entitled 'American Vision,' this contest had no particular theme; there were no categories separating the black-and-white from the color; and as one judge so aptly put it, 'It was like judging apples and oranges'—there were so many varieties. My own personal guideline for this contest was the highest quality of what American photographers are shooting today.
>
> Many photos that I chose were in the show, but many that I like were not chosen. Judges can only bring their opinion, their taste, and their experience to a contest—nothing more.

ALVA L. DORN

For more than 20 years, Alva L. Dorn has been writing a photography column, "Photo Hobbying," for the Kalamazoo (Michigan) *Gazette*. His column is syndicated in several other Midwestern newspapers. In addition, he teaches photography at Kalamazoo Valley Community college, appears on TV in a show called "Al Dorn's Photo Lesson," and has recently published a book for Amphoto entitled *One-Minute Photo Lessons.*

As picture editor of the *Gazette* for 28 years, Dorn has had experience on both sides of photo contests. For 17 of those years, he had judged the *Gazette*'s annual summer snapshot contest that is

part of the KINSA COMPETITION. He has also judged several international salons and the Scholastic/Kodak Scholarship Awards contest.

From the point of view of a contest judge, Mr. Dorn offers contest entrants the following advice. "*Impact* in a photograph will attract the attention of the contest judges. Often they view hundreds of entries in a contest or international salon in a single day, so it's obvious they do not have much time to dwell on any photo. . . . Many times an 'in' or 'out' decision is made after five seconds of viewing. . . . But what is *impact*? How do you achieve it?"

As Dorn goes on to explain:

> There is no universal definition of the word impact as applied to photography, but photographers and judges alike probably would characterize it as that quality in a picture that instantaneously captures the viewer's attention, excites his imagination and possibly . . . probably . . . presents the subject in a new and creative manner. There is no universal formula for creating impact in a photograph. . . . Some photographers are naturals in this area . . . others, once they are aware of the need to lift a photograph out of the routine, will work at it and knowingly exercise a variety of techniques to accomplish it. . . . It can mean a quick working combination of eye, mind, and shutter finger. . . . Impact can be produced by an unusual or unexpected use of . . . camera angle . . . cropping . . . or lighting. Everyone's impact is different, but it's that kind of result that brings the most ohs and ahs, . . . and wins prizes.*

Most experienced photographers would agree with Dorn that although difficult to define, impact is a very important quality that produces contest-winning photographs. However, it is not necessary for a photograph to stun the viewer with bizarre or striking techniques. Another aspect of impact can come out of a very "quiet" photograph—one taken simply, with no obvious or unusual techniques or treatment of any of the elements. It can be a quality that emerges when the photographer is so deeply involved in pho-

*Excerpted from Alva L. Dorn's copyrighted column, "Photo Hobbying," Kalamazoo *Gazette* (December 23, 1979).

tographing, and wants so much to make that image, that the power of his or her feeling transmits itself to the photograph, and the essence of what is photographed, which can be anything, is revealed. This is the quality that is so strongly evident in Linda Foard's photographs (winner, Scholastic/Kodak Awards).

There is nothing obvious—no unusual angles, no dramatic lighting—in her work; yet each photograph seems to be full of a life of its own, a life that vibrates and reaches out to touch the viewer. In music, we all know that the gentle slow ballads can have as much impact as the rousing, stomping, dramatic songs. Perhaps impact—quiet or dramatic—is also a quality of something truly right, something very genuine and honest, where every element in the photograph belongs and is in its right place, creating an unforgettable image.

Whatever the definition, impact in a photograph is something all photographers must be aware of, something they must think about and try to comprehend.

GENE THORNTON

Gene Thornton is the photography critic for the New York *Times*, a contributing editor of *Artnews*, and a writer on photography for Time-Life Books and many other publications. He also judges many contests.

Thornton does this because, he says, "I consider that I have a certain obligation to serve as a contest judge because of my position as a photography critic. I also act as a judge because I am a professional 'photograph looker.' I look at different kinds of photographs differently. In the case of contests I pick what's best. I feel responsible only to my own conscience. When I go to galleries as a critic, I pick what I want to write about."

He compares two contests he has judged—the American Vision contest and the *Natural History* magazine contest. He says:

They were both very different. The first had no theme, no separation of color from the black-and-white, and was not pre-judged; it also had tremendous variety, but I am used to variety. One

51

photograph may have been very good from a journalistic, story-telling narrative point of view, another may have been an abstract composition—all different kinds of photographs that I respond to, and so I picked the best one of the different kinds. The overall quality was technically good. Some of the work was very sophisticated (very few kittens), and showed that people are very aware of what's in style, what's *au courant*. The *Natural History* magazine contest had definite themes and categories; it was pre-judged, and smaller. Because of its specific themes, one could use standards, or more definite criteria, in the judging, and therefore more easily pick the best one in the various categories. It took a morning to judge the *Natural History* magazine contest, and two days to judge the American Vision contest. Some photographs just stand out, maybe because they are eccentric, which gives them some distinction. Maybe it's all a "new kind of badness."

HARVEY FONDILLER

Harvey V. Fondiller is a photographer, an editor, a writer on photography, a critic, and a teacher. As such, he is frequently called upon to judge photo contests. Additionally, he has been a winner in many contests, and so knows about contests from both angles. As he describes it:

When I am a member of a judging panel, this is what happens. First we look at everything, to get the overall level of competence. Then comes a series of viewings to eliminate from the bottom. Anything that does not meet the contest's regulations is automatically eliminated. For instance, a hippopotamus has no place in a pet photo contest. A judge must know how to say "out!"

By progressive eliminations, we reduce the number of contenders until the number of remaining photographs matches the number of prizes and honorable mentions. If there are three prizes and two honorable mentions, we pick the two honorable mentions first, and finally we discuss the three remaining photographs and rank them first, second, and third. Usually, a competent rendition of a complex or difficult subject takes precedence over a rudimentary interpretation, though human interest is an undeniable factor.

SEAN CALLAHAN

Sean Callahan is the editor of *American Photographer*, a magazine that received the Photographer of the Year contest's Editor's Award. The same year another top prize was awarded to Callahan and to W. Hopkins, *American Photographer*'s art director, as editors. Out of a possible five prizes, two went to American Photographer and its top staff.

American Photographer runs a regular section called "Assignment," which Callahan considers a kind of contest. An idea line or phrase is given—something like "Plain and Fancy," "Shooting Stars," "Stars and Stripes"—and readers are invited to submit pictures illustrating or interpreting the idea. Callahan estimates that he receives between 500 and 800 submissions every month, and he looks at all of them. About 5 or 6 get published, each photographer getting $25 per photo. Although this is comparable to a contest, it is also like fulfilling an assignment. At first, Callahan asked professionals to submit work, but he discovered that the readers' work was better than the pros, since the pros often could not take the time off to work out the concept. Now the monthly contest is for readers only.

When asked how he judges a contest, Callahan replies that he does it just like editing. "I quickly go through everything to get the general level of submissions, and to compare the work. Most people don't realize how quickly a picture professional can go through pictures. You like it or you don't like it. It's entirely subjective. You can only bring your own viewpoint to a contest judging. It's instinctive."

CHARLES REYNOLDS

Charles Reynolds, picture editor of *Popular Photography*, estimates that he has judged "hundreds" of contests sponsored by all kinds of groups: schools, colleges, professional organizations, equipment and film manufacturers, museums, cultural societies, in-house company groups, camera clubs, and journalistic associations. He is always delighted when he finds unexpectedly high quality, and is

always on the lookout for something good for the magazine. When he finds something publishable, he considers this an extra bonus.

For example, Reynolds uses a photograph of a child (not the first-prize) from the "Great American Face" contest as a cover for *Popular Photography*. He also points out that the photograph of the Peruvian fluteplayer on the cover of the paperback edition of the well-known book *The Family of Man* had been a winning photograph in a *Popular Photography* contest (this contest is no longer held).

Being a judge at contests, he says, "is a way of paying my dues. It is an extension of being a picture editor. I bring the same sensibilities to contest-judging that I bring to my picture-editing job."

Reynolds is always looking for new photographers, and being a judge is a way of finding material that might not otherwise reach him. He is particularly interested in what is coming out of the colleges, and is a judge at many college contests so that the magazine can publish more student work. He finds that his opinions very seldom differ from those of the other judges, and is "amazed at how unanimous the agreement usually is."

The opinions and views expressed by these contest judges, and the descriptions of some actual judging sessions, should be helpful to prospective entrants, and should also satisfy their curiosity about how entries are reviewed and judged.

To provide greater insight into judging procedures, here is a detailed, step-by-step instruction sheet used by the judges at a national contest sponsored by the Campfire Girls. The instructions to the judges are basically similar to the judging procedures used at all good contests. They represent a sincere effort to be as fair as possible.

CAMPFIRE GIRLS NATIONAL PHOTO CONTEST: JUDGING PROCEDURES

1. The judges will review black and white entries first.
2. They will review black and white entries in the different cat-

egories separately: 6–12 years old, 13–17 years old, adult or parent.

3. Each judge will select as many pictures in each category as she or he wishes to have considered for recognition.

4. The pictures will be arranged in random order on the table for final consideration. Judges will view them and discuss their merits.

5. Within each category, a minimum of four pictures will be selected by hand vote. More than four pictures may be selected.

6. If a judge feels strongly about an entry remaining in consideration, the judge may have the floor for sufficient time to present the case for it and to call for a new vote.

7. Entries to be considered for the final judging will be checked to insure that a person participating as a contestant is not represented in the final judging by more than one entry. If more than one entry from such a person is represented among finalists, the judges will select the best and award the other or others Certificates of Merit.

8. When four or more photos have been selected for final judging, a secret ballot will be taken using a point system of one to ten points per picture.

9. Reballoting will take place if needed to eliminate ties or if requested by a judge.

10. Temporarily, until a decision is made regarding the Grand Award in each age category, the picture receiving the highest number of points will be designated for the Award for Excellence. The picture receiving the next highest number of points will be designated for Citation for Distinction. The remaining finalist pictures will be designated for Letters of Merit.

11. The procedure will be repeated for the color entries with whatever adaptation is required because of projection of slides.

12. The best pictures in the black and white and in the color classifications in each age category will be considered for the Grand Award Trophy in each category. Winner will be selected by secret ballot, using the ten point system.

13. When a picture is selected for a Grand Award Trophy, it will no longer be designated the best picture in its category. This designation, for excellence, will be given to the picture that

received the second highest number of points in the category. In turn, a new second place winner will be designated, for distinction, from winners of the Certificate of Merit in that category.

14. While only one photograph is to be selected for each of the Grand Award Trophies, and one for each designation for Excellence or Distinction in the age categories in black and white and in color, no limit has been placed on the number of Certificates of Merit to be awarded. Certificates of Merit may be awarded for all photographs selected by the judges as worthy of mention.

CHAPTER 6

Interviews with the Winner-Makers

There are two annual nationwide photo contests: the Pictures of the Year (POY) contest and the Scholastic/Kodak Photography Awards competition. Both these contests have been in existence since the 1940s. Both contests are also restricted: the POY to working photojournalists and the Scholastic/Kodak contest to high school students.

Over the years, an unusually high number of Scholastic/Kodak winners have come from two high schools: Reseda High School in Reseda, California, and Myers Park High School in Charlotte, North Carolina. Similarly, a consistently greater proportion of POY winners have shown either current or fairly recent histories of employment with the Topeka (Kansas) *Capitol-Journal* than with any other newspaper in the country. Since it is statistically unlikely that this rather top-heavy proportion of winners is a matter of pure chance, we must conclude that each of these organizations has a person or persons on its staff who possesses the rather extraordinary ability to elicit consistently superior standards of work. These are the winner-makers: Richard Clarkson, Director of Photography of the Topeka *Capitol-Journal*, and photography instructors, Warren King of Reseda High School, and Byron Baldwin of Myers Park High School.

Because it is probable that what these winner-makers think and have to say about photography and photo contests will be of great interest to prospective contest entrants, they have been interviewed for this book. It is hoped that the extraordinary influence they are able to wield will be transmitted to the readers.

RICHARD CLARKSON

It is a matter of record that over the years. Topeka *Capitol-Journal* photographers have won an unusually high number of POY prizes, either while working on that newspaper or soon after moving on to another newspaper. For examples, Chris Johns of the *Capitol-Jour-*

nal won the 1978 Newspaper Photographer of the Year, the POY's top prize, plus honorable mention in two individual categories: Feature Picture Story and Sports Picture Story. This is quite an achievement when one realizes that each year over 10,000 entries are submitted to this contest by more than 8,000 photographers working for newspapers throughout the country.

Richard Clarkson, the *Capitol-Journal*'s Director of Photography, feels that his first responsibility is to maintain the high level of photography that was established long ago on that newspaper. Clarkson edits, assigns work to the staff photographers, and briefs them; he also photographs and writes. "I like being involved in all these different disciplines," he says, "and after a bout with one, I return to the others refreshed and enthusiastic."

Part of Clarkson's effectiveness may be due to the fact that he was and still is a photographer. This is not true of most picture editors. Earlier in his career, Clarkson worked for the *Saturday Evening Post, Life*, and *Time*; he is presently a contract photographer for *Sports Illustrated*, for whom he covers important events.

QUESTION: *How did the Topeka* Capitol-Journal *attain its excellent reputation, and such an outstanding record of prizewinning photographers?*
CLARKSON: Tom Kiene (now retired) was an editor for a number of years before I joined the paper, and he was receptive to ideas for increasing and heightening the role of photography on the newspaper. He felt strongly that photographs should be a more important part of the paper, and should be used well. This "good photography" reputation spread, and the paper became known as a place where serious and talented photographers wanted to work. It also became known that a job with the Topeka *Capitol-Journal* was a good steppingstone to other jobs.

So, logically, a paper that strives for what's best in photojournalism gets good photographers, and a situation is created that encourages the photographers to do their best and, finally, leads to top awards regularly in national competitions.

QUESTION: *What advice can you offer people interested in entering contests?* (Note: Clarkson's reply is geared to working photojournalists, but his ideas and thoughts can be applied beneficially to all photographers.)

CLARKSON: If the photographer is too concerned about a contest, about winning, it can distract from doing top-notch work. One must forget about the contest, and think first of the work, of producing the best possible pictures. Only then should one become concerned about the contest. However, winning is very very useful to the young photographers when getting a career started. And if you do enter, you must be prepared to thoroughly enjoy it when you win, and keep it in perspective.

For the working photographer, the ultimate goal should not be to win contests. There's a delicate point of crossover: some worry all year, and think of creating a portfolio to enter, which can be$a detriment to the career.

The idea of the contest was secondary to Chris [Johns]. He was more concerned with journalistic honesty—with picture content, with putting the reader first, with being responsible to himself and the public, and with a dedication to taking pictures that would communicate. His first concern was being the best photographer he possibly could be.

QUESTION: *What do you feel constitutes good judging procedures, and a good and fair contest?*
CLARKSON: I feel that a good judge in a photojournalism contest, such as the POY, will know the memorable pictures of the year, and must have integrity. I disqualified myself when Chris Johns's portfolio reached the finals of the 10 portfolios up for the top prize.

The POY has been held for many years, there have been many evolutionary changes; it has become more sophisticated in both the entries and the judging. Angus McDougall [Professor at the School of Journalism at the University of Missouri in Columbia], who is the contest director, is constantly refining the procedures. At one time an audience was allowed in to watch the judging. However, the audience kept growing—people would drive in from thousands of miles away. Feeling that the "grunts" and "groans" and "aas" from the audience might be influencing the judges unduly, and that perhaps some of the judges were playing up to the audience, he did away with having an audience. Professor McDougall is even concerned with the shape of the room where the judging takes place, and the lighting, and when the judges should break for coffee.

When I was chairman of the contest committee, with the responsibility of picking the judges, I was always careful to choose judges from diffepent areas of work—editors and photographers—and of different tastes, and from different parts of the country. ...

Photographers should be aware that there are three kinds of pictures which will affect the reactions of the judges: (a) Pictures that need no captions, no background information; the photograph is self-contained, a universal theme; (b) Pictures for which the viewer already has the information: a photograph of a well-known personality, the President, the Queen of England, the Pope; or a well-known event, such as the play that won the World Series; (c) Pictures that are similar to the winner of the year before. For instance, Brian Lanker [presently Director of Photography of the Eugene (Oregon) *Register-Guard*], won in the POY several years ago when he was on the Topeka *Capitol-Journal* with pictures of a natural childbirth. For several years after that, other newspaper photographers went out and photographed the same subject, and submitted similar portfolios to the POY. None were awarded the prize. (Photographers will do this almost inadvertently, and this applies to people entering all kinds of contests).

Good on-the-spot news photography is difficult; it requires the ability to photograph quickly without preliminaries, and it is not easy to catch the essence of the subject or event. Feeling that Mr. Clarkson would have a deep understanding of this special ability, we asked him if he could explain it for the readers of this book. He replied:

Good news photographers are so intensely concentrated on what they are photographing, on what's in front of them, they think only of getting it recorded as best they can, and so they lose an awareness of themselves in connection with the action. It's as though they themselves disappear.

Some people naturally have this kind of unselfconsciousness, this kind of total concentration; but it is also an ability that can be practiced and acquired, and photographers interested in taking news-type pictures (or any kind of good pictures) should work on getting this kind of directness and immediacy into their work.

WARREN KING

Warren King has been the photography instructor at Reseda High School since 1955. Over the years, his students have won more national awards than the students of any other high school in the country, with over three hundred winners in the national Scholastic/Kodak Awards contest, and nine top scholarship winners in nine years. Students of King have also won seven full scholarships at the Art Center College in the United Crusade competitions, and many more contests.

During World War II, King was a combat cameraman, and on his return to civilian life in 1946 he took up commercial photography and documentary filmmaking. During this period he also began to teach photography, and soon realized that this was his true calling. In 1955, he initiated the photography program at Reseda High School, one of the smaller schools in the Los Angeles Unified School District, and through the outstanding work of his students he has attained a nationwide reputation.

To reveal to the readers of this book what King gives to his students, he was asked a number of questions about the value of judging, winning and losing, and evaluating contests. In addition, he was asked to comment on photographers, on the details of conducting school contests, and on his methods of motivating his students to achieve such an outstanding record.

QUESTION: *Do you think entering and winning contests can help people move into professional careers?*
KING: I encourage my students to enter as many contests as possible in order to get various viewpoints on their work. We downplay the importance of winning because, as many judges have mentioned, their attitudes vary by the day.

I can't really relate to any situation where I feel winning a particular contest has contributed to their entering photography professionally, although having won a major competition is a strong factor in their resumes. It also gives the student a real boost psychologically to have done well in a major competition.

QUESTION: *When you are a contest judge, how do you approach it?*
KING: I have done quite a bit of judging and generally look for originality, creativity, print quality, and overall impact. Impact

can be a result of all of these points. The Photographic Society of America has invited me to a few of their competitions as a judge, but I am in constant disagreement with the other judges as I feel they look for sharpness and prettiness more than much on the creative side. I do not like using point systems and computers. I feel judges should be able to express their opinions and argue their points.

QUESTION: *How do you handle the reactions of those students who have entered a contest, done a lot of work, and not won?*
KING: Disappointment at not winning a contest is a constant problem, and *I* am disappointed even if a student is not. I like them to feel that every print they enter is good enough to win, but also to realize that someone else can possibly do better. It is up to the student to analyze the reasons another print may win—and to understand that judging is only an opinion.

QUESTION: *In which other contests, besides the Scholastic/Kodak Awards contests, have your students been winners?*
KING: The Los Angeles *Times* annual contest, Photography West, Coca Cola's America the Beautiful, the United Way contest (seven consecutive scholarships to Art Center College and three national first-place winners), Focus (sponsored by the National Photo Instructors Association), Photographic Society of America (five national first-place winners). In the past 24 years, the Reseda students have had more than half the total of the winning prints in the Los Angeles County Fair competitions, one of the largest in the country; five of these were Best in Show.

QUESTION: *Please tell us about some of your students who were past contest winners, and are now practicing photography professionally.*
KING: It will be difficult to name winners of the Scholastic/Kodak Awards contest who have moved into the profession because we have had well over three hundred of them, but here are some of the nine top scholarship winners; the more recent ones are still students on the college level.

Ron Contarsy, the $1,000 winner in 1972, is now a photographer with a major ski magazine.

Gil Smith, the $500 winner in 1972, is now a commercial photographer in Los Angeles with several national accounts. He

had also won a United Way scholarship to the Rochester Institute of Technology.

Joan Trindl, the $1,000 winner in 1973, was teaching photography, and is now pursuing a college degree.

Jeff Widener won an all-expenses-paid trip to Europe and Africa in the Scholastic/Kodak contest, in 1974, and is now a successful news photographer in Oregon.

Dan Steinhardt, $1,000 winner in 1976, is now a successful commercial photographer in Chicago.

These are just a few, but I would venture to say that more than fifty who have won awards are now leading professionals in the field.

The United Way at one time offered scholarships to Art Center College, and most of these recipients have become professional photographers. One who comes to mind is Tim Brehn. He completed the four years at the college and entered the professional field with good success. But when he noticed that I was getting more satisfaction in my work than he was, he decided, with my encouragement, to enter the field of teaching; today he is one of the leading photography instructors in the country.

QUESTION: *Please describe in detail a school contest that you sponsor: its organization and judging procedures.*
KING: I feel our own schoolwide competition is the best example in answer to this question. It is an annual competition held near the end of the school year, and we hang over 2,000 prints. We do not screen the prints, but encourage the students to show prints they have pride in, and never to put any two prints in that are in the least bit similar.

We have evening adult classes as well as the regular day school program, and the adult classes are limited to three prints per category, to ensure top quality. The categories are: Studio Portrait, People in their Environment, Sports, Commercial, Scenic Pictorial, Human Interest, Creative, Open, and Color.

We use a separate unit of four or five judges for each division, and this year, for the first time, all of the judges were former students who now own their own studios.

The first thing the judges must do is to select the "Photographer of the Year" by viewing portfolios of ten prints each and not discussing them—merely making the selection. These prints are then distributed into the various stacks of categorized prints

where they will be judged per category. An entire category is then put up along the wall, and the judges walk past them once for familiarization. The second time around, they pick up prints they like and bring them to the front of the room where they are lined up about twelve feet in front of the judges' chairs. Then the judges comment on each print. The judges' comments are taped for playback before the students (one of the best learning experiences they encounter), and then the selections are made. We generally give first, second, and third places plus honorable mentions in each category. In addition, a Special Award ribbon can be given to a print by any single judge. The judging session usually takes about six to eight hours, and members of our photo club cook up a nice dinner for them to break up the session in the middle.

We do not allow the students to watch the judging. We feel it might inhibit the judges to hear comments or moans and groans while they judge. At the end of the judging, all the first-place prints are lined up, and the judges must decide Best in Show. As mentioned before, we have two separate units of judges working in two separate rooms. It is a very busy evening.

It then takes a day or so to get all the ribbons on the prints, and to get them in order for the presentation of the awards. The cost of the ribbons is taken care of through club dues. The first-place winners receive engraved plaques which are financed by our local Kiwanis Club.

The presentation of awards takes place at our Annual Banquet, for the day and evening schools combined. Generally, between 250 and 300 people attend at a large restaurant. The awards are all kept a secret until this time, so everyone looks forward to the event. At the banquet we also feature about six of the top slide shows of the year. When the winning prints are announced volunteers carry the prints through the audience for close viewing.

There are several adults who attend the banquet every year just to be there, and they have nothing to do with the school. We talk up the Salon throughout the year, and the students treat it like the biggest event in their lives, both the adults and high school groups.

We've had 24 of these Salons, and they get bigger and better every year. This year we had over 10,000 visitors view our show. It is open one day and two evenings. Even tearing down

the show is a festive occasion. All the students take part and then go to an ice cream parlor afterwards for the annual "tear down" party.

One of the most positive aspects of the show and competition is that many professional photographers come to see it, and many of the students have obtained jobs through having their work displayed.

QUESTION: *Can you explain how your methods have motivated your students to achieve such an outstanding record?*
KING: I find it difficult to explain in any way why my methods might be any better than or any different from than any other instructor's, except that I feel I enjoy my work and my students more than any other instructors I've ever met, and I hope that others feel the same about their work. I'm not striving to be any better than anyone else.

I offer my students challenges every day, and they, in turn, challenge me to try a little harder to find a new means of forcing them to solve a problem. The students do all the work and it seems I end up with whatever glory that might be attached. Glory is not very tangible, and it doesn't add to the income, but it is nice to hear that someone feels you're doing your job well. It's this attitude I try to spill upon my students, and they do respond.

Learning technique before the push on creativity, I feel, gives the student a stronger background, and more confidence in doing his work.

In 1978, Warren King's daughter, Susan, shared the $2,000 scholarship award with Gary Weinreb (a student of Byron Baldwin, who is interviewed below.) About this, King says:

Believe me, it was difficult for both of us for her to win the honor, but I guarantee that it was she alone who did the work, and she probably had less help from me than almost any other winner we have had in the past. As a student, she pretty well kept her distance for fear of rocking any boats with her peers. It was a very exciting event for the whole family, though.

Warren King's achievements have not gone unrecognized. He has been the subject of many magazine and newspaper articles. In 1972, he received the C.A. Bach Award* from the Photography Instructors Association for outstanding contributions to photographic education. In 1973 he was named the Los Angeles City "Teacher of the Year." He has been the subject of two sessions of the NBC-TV talk show "Talk about Pictures—one session about his own work, the other about his students.

BYRON BALDWIN

For three consecutive years, the top award of $2,000 in the national Scholastic/Kodak Awards Contest was won by one of Byron Baldwin's students from Myers Park High School. In 1977, the prize went to Alice Sebrell; photographs she took while still a student at the University of Delaware are in the permanent collections of the Greenville (South Carolina) County Museum; the R. J. Reynolds Foundation; the University of the South; and the North Carolina State Museum of Art. In 1978, Gary Weinreb of Myers Park split the top award with Susan King of Reseda High School. In 1979, the winner was Linda Foard. Also in that year, 14 out of 300 other awards for single entries in the different categories went to Baldwin's students. On a nationwide basis, this is an outstanding achievement, especially since there are only 12 students in Baldwin's second-year photography class.

Baldwin started teaching photography at Myers Park High School in 1971. He had come to photography by a circuitous route. A history and political science major in college, his hobby was photography. While serving in the Navy, he began to do more and more photography. And after finishing his service, entered graduate school to pursue this interest. Although the instructors did not give him much inspiration, it was at that time that he became really

*C.A. Bach was a photography teacher at Fremont High School in Los Angeles. He taught over 500 of today's outstanding photographers, 9 of them on the staff of *Life* magazine.

committed to photography. Upon graduation, he took a position as a commercial photographer, but found the work unsatisfying. When an opening for a high school photography teacher became available, he applied, was accepted, and thus discovered his true profession.

Paradoxically for someone who has had such success with contests, Baldwin is not too enthusiastic about them. "With reservation," he says, "I don't care for competition. But I feel it's good for self-discipline, it's a way of determining how much good work you can do, and the cash awards and publication of the work are indeed gratifying."

Baldwin believes his teaching methods involve considerable deviation from the traditional roles of teacher as lecturer and student as passive listener.

The main thrust of Photography I is to make the students visually aware. Learning to use a camera is fairly simple. The hard part is learning to see good pictures. The students work with their own cameras or borrow one from the school. After the ground rules of an exercise are laid down, they're on their own. The most difficult part is deciding what to photograph. In Photography II, the next year, they get more freedom, more team spirit and greater peer pressure to do well.

In the second year we also go into more technical things, like using different cameras, (35 mm, 2¼, and 4 × 5), processing, and also filmmaking. I emphasize that they must learn to work well together. I also show them that photography can wake people up to a greater awareness of the world, and themselves.

People are receptive to the technical aspects of photography. In the beginning they are impressed by the instruments. But I quickly get beyond that and tell the students that 90 percent is the head, and 10 percent is the camera.

Decision-making is an important part of learning. I never tell the students what to photograph. I give them an idea and let them figure things out.

When students learn to work well together, a whole lot of energy comes out. It tends to feed on itself and create more energy. One of the duties of the teacher is to keep that harmony going. A good class is one in which students learn as much from each other as they do from the teacher. They produce work to-

gether—it's a two-way street. And, there are always a few students each year who have something to teach me.

I work to keep the level of energy high; when it flags, I step in. At one point when things slowed down, I put them in a circle, and assigned them to photograph the student on either side, to go out and work together, and so generated activity outside of the school, to relate to each other. I give them direction, and then I get out of their way.

As part of his teaching program, Baldwin runs a weekly competition called the "Friday Photo." All photos entered must have been taken since the preceding Friday. No excuses are accepted for not having a picture, and it is a rare occasion when someone does not have a photograph to submit. In the more advanced classes, each week a different student is appointed "judge," and required to give a critique of each photograph (Baldwin judges the first-year students' work).

"Taking a decent photograph every week is not that easy," says Baldwin. "The photos stay up for a week, and if your photo is not up to standard, it gets pretty hard to live with by Wednesday or Thursday. Often the following week, the people on the bottom will get a top position. I do the assignments too, and since I have a grueling schedule, it's difficult for me to give the assignment sufficient time, and sometimes mine are terrible, and have been on the bottom. It's a humanizing experience."

Linda Foard, the national top 1979 winner, "absorbs the being-ness of what she photographs. The first year she was good, but in the second year she really came out. It takes time to figure things out. Progress is never even, there seem to be certain jumps. Once they figure out why and what they're doing, the development feeds off itself.

Linda Foard's analysis of her own learning process is considerably simpler: "We respect [Baldwin] so much, we want to please him and please ourselves," she says. And Gary Weinreb, the top Kodak/Scholastic winner in 1978, also credits his success to Baldwin's influence:

He teaches you to express yourself beyond the technical. He forced me into the contest as a challenge with clearly defined lines, and I put out a lot of effort in about three months. Although I'm not competitive, contests are great in some ways, and I worked at it intensely. Entrants should realize that though the judges don't always judge on the same principles as the one who photographs, I'm pleased that I won.

CONCLUSION

It seems paradoxical that these "winner-makers," and their winning students, underplay concern for winning as the ultimate goal. Rather, their basic message is "Do your best and don't think about winning." Each of these winner-makers emphasizes primarily the concept of a deep responsibility to the work, to oneself, to the viewer. Each creates an atmosphere that fosters the highest esteem for the medium of photography, and a strong desire to do one's best. If you, the reader, can create this attitude for yourself, you may find that you, too, will become a better photographer—and, perhaps, a prizewinning one.

CHAPTER 7

Contests as a Way to Go Pro

Contests can be a pathway to a professional career, because getting accounts and producing work to satisfy clients is similar to the work involved in entering contests. Whether you win or not, entering contests can be good training and preparation for a professional career. And if you should win, the psychological boost is invaluable.

Roy Pinney used contests at the outset of his career to get attention, to acquire "credentials," and to make some money. He won four very big contests in a row, which finally brought him some advertising accounts. Once that happened, he never entered a contest again.

Pinney notes that he was always very careful to study the regulations, and to try to find out who the judges were. If several submissions were allowed, he would always submit a variety—portraits of babies and attractive young women, pictures of animals, and scenics.

This writer also used a contest for the same reason that Roy Pinney did—to achieve some recognition. A monthly magazine ran a contest to find beautiful young women, not professional models, for their covers. The prizes were $2000 for the photographer and $1000 for the model. A friend who worked at a college was helpful in locating a truly outstanding beauty. Winning the contest not only provided the money for new equipment, but also was invaluable in increasing confidence and courage as a photographer. Success in the contest led to a travel assignment to Scotland from a major magazine for six pages of pictures. So, winning the contest was truly a decisive factor in starting a professional career in photography.

While still high school students, Jack Manning, now a New York *Times* staff photographer, and Harold Corsini, who became a leading industrial photographer in Pittsburgh, started a nationwide high school photography contest. Their faculty advisor helped them get in touch with schools around the country, and succeeded

in getting Margaret Bourke-White and Victor Keppler, both *Life* magazine staff photographers, as judges. Despite the fact that the judges did not know which work belonged to which photographer, Manning and Corsini won most of the prizes.

The late W. Eugene Smith, who was selected as one of the world's ten greatest photographers in a poll conducted by *Popular Photography* magazine in 1958, won two *Popular Photography* contests early in his career. He won the first in 1942 for a World War II battle scene, and the second in 1948 for the widely reproduced "A Walk in Paradise Garden," a picture of two small children silhouetted in a patch of sunlight in a forest.

W. Eugene Smith's great contributions to photography are his World War II photographs and his unforgettable picture stories for *Life* magazine, now preserved in books: *Life in a Spanish Village, Country Doctor, Man of Mercy* (about Albert Schweitzer's medical work in Africa), *A Nurse Midwife,* and *Chaplin at Work.* He also produced a voluminous foundation-supported study called *The Pittsburgh Story.* His 1975 book *Minamata,* depicting the tragic effects of mercury poisoning in a Japanese fishing village, contributed immeasurably to the world's awareness of the dangers of environmental pollution. His list of accomplishments also includes other books, many foundation grants, and gallery and museum exhibitions.

Dennis Stock, a photo-essayist, has built a distinguished and varied career that includes more than 20 photography books; a great number of articles in almost every major magazine; and important museum and gallery exhibitions, including a retrospective in 1977 at the International Center of Photography. His work is also included in major collections. He has made documentary films, conducted many workshops, and given lectures, and has been featured on educational television.

When he was still an apprentice photographer, in 1951, he won first prize in *Life* magazine's Young Photographers contest, for which he received an award of $3,000. He regarded that win as a graduation diploma to full professional status. As a result, he was invited to join Magnum, an international cooperative of some of the world's best-known photographers, of which he is still a member.

Three other Magnum photographers, Charles Harbutt, Constantine Manos, and Bruce Davidson, all won high school photography contests.

Conrad Lovelo, Jr., never won a photo contest, but he entered many of them over a period of years and used them as stimulation and practice until eventually he could and did establish a photography business. He is now the director of a unique photographic enterprise consisting of a fine photographic studio, a photo store, a school of photography (pupils come from local high schools), rental darkrooms, and a phototypesetter used to publish *Photo Insight* (see Chapter 3), a newsletter carrying news of many current photo contests. Since the kind of business that Lovelo has established develops very close ties with the people of the community, he has also been instrumental in starting a community newspaper which uses the photographic and writing skills of the photography students and is completely produced on the premises.

This flourishing enterprise was established modestly in 1972. Lovelo, who spent the first 20 years of his working life as an air traffic controller after 8 years in the U.S. Air Force, says of this change in careers: "From an early age, I always wanted to be a photographer, and I sustained my interest in it during that period by entering photo contests—'thousands' of them. I never won; I just received a few honorable mentions. But I kept at it, and used the stimulation of the contests to spur me on, to give me ideas, and to improve my skills."

It was because of this strong interest in photo contests, coupled with the realization that there was no single source of contest announcements, that Lovelo started the newsletter in 1974. It has since grown from an 8-page to a 32-page magazine.

After the many years of practice taking pictures for the contests, Lovelo finally took some formal photography courses, and decided with his wife, Jacqueline, to take the plunge in 1972. He opened a studio near their home because "I saw a need in my immediate community for a photographer with feeling."

Among the first commissions were high school yearbook pictures. This was the beginning of public interest in the Lovelo's new enterprise. Their reputation grew, and now many people seek out their photographic services for many purposes: children's por-

Al Dorn won a station wagon, the top prize in the 1960 *U.S. Camera* magazine international black-and-white contest, with this picture of five smiling kittens.

Susan King of Encino, California, submitted a color print of this photograph as part of a 12-picture portfolio which won a $1,000 scholarship in the 1978 Scholastic/Kodak Photo Awards contest.

Mike Hope, a 13-year-old Boys' Clubs of America member, won a special Merit Award for this self-processed black-and-white photo entitled "Profile."

This high-contrast print won an Honor Award for Alice Hall in the 1973 Scholastic/Kodak competition.

This photograph was part of a portfolio which won a $1000 scholarship for Gary Weinreb in the 1978 Scholastic/Kodak Photo Awards competition. Gary was a student of winner-maker Byron Baldwin.

Lida Moser won a merit award in the Ilfospeed Print Contest for her photograph of this silhouetted and curious cat.

Alice V. Sebrell, of Myers Park High School in Charlotte, North Carolina, won top prize in the Scholastic/Kodak Photo Awards competition in 1977; this photo was part of her 12-picture portfolio.

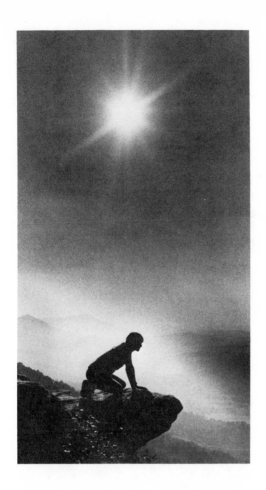

Eleven-year-old Robbie Cater won Grand Prize in the 1979 Boys' Clubs of America photography contest for this work entitled "The World Awaits."

This photo for an assignment called "Painting with Light" won awards from three different competitions for photographer Linda Rogers, including the Gold Medal from the New York City Metropolitan Camera Club Council in 1976.

Chris Johns, of the Topeka *Capitol-Journal*, won the POY Best Newspaper Photographer of the Year award with this photograph of a father kissing his young son through the plastic wall of an oxygen tent.

"The Agony of Defeat" is the title of this telling photograph by S/Sgt. Daniel C. Perez, USAF. It won first place in the Sport Division of the 1978 Military Photography of the Year competition, part of the POY.

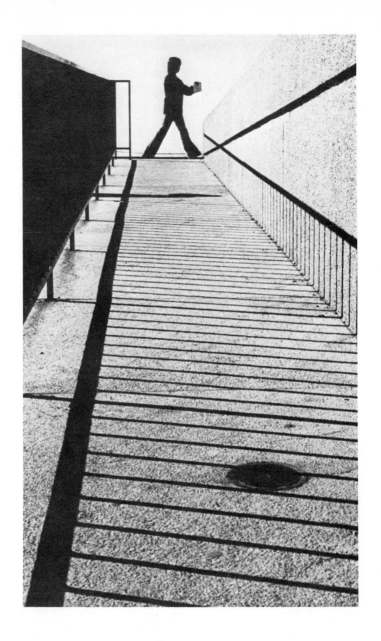

This photograph was part of a portfolio submitted by S/Sgt. William Boardman, USAF, for the 1978 Military Photographer of the Year competition.

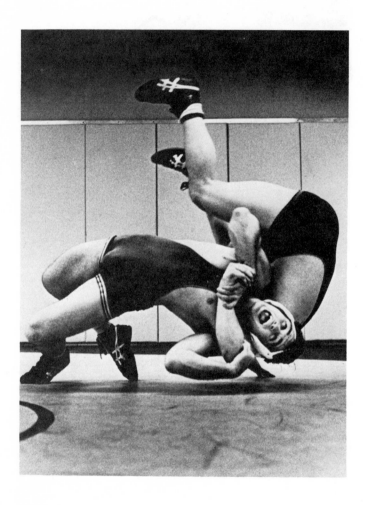

SP/4 Manuel Gomez of the U.S.
Army won second place in the Sports
Division of the 1978 Military Photog-
rapher of the Year competition for
this photo entitled "Three Point
Battle."

This beautifully evocative photo-
graph entitled "Going Home," won
second prize for SP/4 Manuel Go-
mez, USA, in the feature division of
the 1978 Military Photographer of the
Year competition.

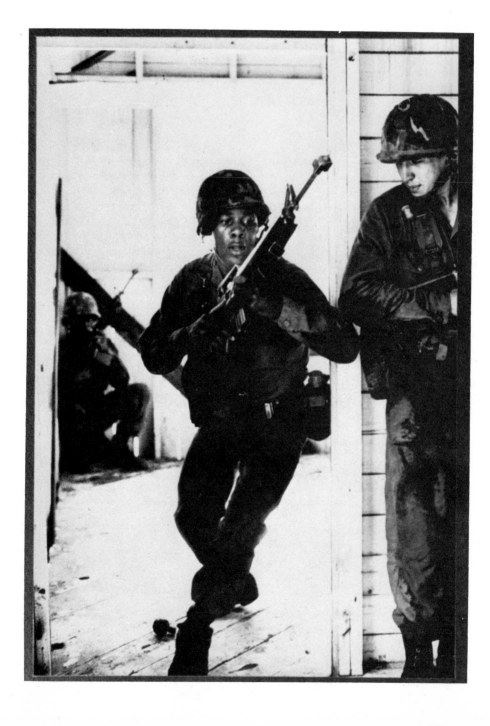

This mounted portfolio by SP/4 Manuel Gomez, called "Adding Reality," appeared in the 1978 Military Photographer of the Year competition.

These three photographs were part of
Linda Foard's top prizewinning port-
folio in the 1979 Scholastic/Kodak
Photo Awards competition. Of
Foard's work, her instructor, Byron
Baldwin, says, "She absorbs the
being-ness of what she photographs."
Her work is quiet, very sensitive, and
totally lacking in "POW" quality.

These are not Moslem women, but a group of boys at a Star Wars swim party in Hamden, Connecticut. The photo won third prize ($300) in the 1980 American Vision contest.

This is one of the superb photographs produced by Leon Kuzmanoff, who won the Grand Prize (a $15,000 contract) in the 1970 *Life* magazine photo contest, probably the biggest photo contest of all time.

Jack Jeffers's "Mountain Man" won best-in-show in an art exhibit open to all media. Jeffers received a cash award of $250 over entries in categories of oil, acrylic, watercolor, sculpture, graphics and drawings, and other media.

S/Sgt. Randall G. Lovely, USA, received an honorable mention in the Portrait/Personality division of the 1978 Military Photographer of the Year competition for his photograph "Maria and Marcelino—Mexico—1978."

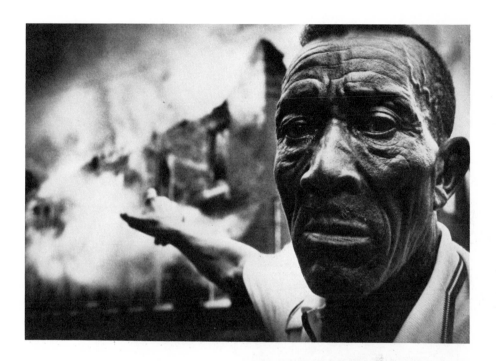

PH/1 Michael P. Wood, USN, took
second place in the News Division of
the 1978 Military Photography of the
Year competition for this haunting
photograph, "Everything I Own."

"While You Sleep" is the title of this
beautifully lighted, low-key photo-
graph that S/Sgt. William Boardman,
USAF, submitted as part of a port-
folio to the 1978 Military Photogra-
pher of the Year competition.

"Have a Seat," by PH/3 R. K. Hamilton, USN, won second place in the pictorial division of the 1978 Military Photography of the Year competition.

traits, wedding pictures, anniversary photos, and pictures of other important events.

After much persistence, the Lovelos were finally able to get fully involved in the work they care about, and make their many-faceted enterprise grow and prosper. This is an unusual example of someone using photo contests in a very intelligent way—both as an introduction to a career (through contest participation) and as a career itself (through the contest newsletter).

Jack Jeffers of Lyndhurst, Virginia, used contests to make a transition from advertising and sales promotion to professional photography. While still involved in his first career, he began entering photography contests—about three dozen Photographic Society of America competitions and a *Southern Living* magazine contest in which he won second place. Concerning the prize he won, he writes, "I had one heck of a time getting rid of an electric golf cart which blocked my carport for several weeks." While the contests have helped Jeffers to see how his work measures up against that of others, his commitment is to photography as an art form. "My ambition," he says, "was to compete not only against other photographers, but against the entire field of arts—painters, mixed media artists, potters, sculptors, and the like." He continues:

> At the present time, I sell photographs via the art shows, in Virginia, Connecticut, Florida, and points in between. I have also had many one-man shows in galleries, primarily in the Virginia and North Carolina area, and I also sell directly out of my own studio gallery. Out of the 200 big shows I've entered, maybe a third of these were judged on the spot, meaning nice cash awards in addition to direct sales out of the booth. I figure that I've taken awards in 90 percent of these.
>
> Every year thousands of art shows are held across the country in coliseums, convention centers, and on the streets. These shows give working artist-photographers an opportunity to meet the public face-to-face, to continue the quest for recognition, and they also afford us the opportunity of selling our work.

After deciding to switch from photo contests to a professional photographic career about ten years ago, Jeffers was often turned away from art shows. He did not give up, however, and

eventually the barriers against photography came down at many of these art fairs. In 1977 he won a gold medal at the Outdoor Art Festival in Mystic, Connecticut, the largest sidewalk art fair on the East Coast. He also won best-in-show in an all-media art show at the Waynesboro-East Augusta Art Festival in Virginia in 1972.

Jeffers has also published a book of his work, *Windows to the Blue Ridge*, which sold over 6,000 copies, and he is working on a new book. His photographs and writing have appeared in over 30 magazines and newspapers. He also lectures, talks on the radio, appears on television, and teaches at Blue Ridge Community College. The main point of his classes is the use of the camera as a tool in the creative process.

Jeffers lives in a rural area, and has compiled a very large collection of stock photos of rural life in the Appalachian mountains. He also stocks transparencies for calendars, travel brochures, annual reports, and similar publication. He does a limited amount of commercial illustrative work, "for the bread and butter, despite the fact that I'm so far out in the sticks."

However, his heart is in fine art photography, and through his commitment and persistence, this is fast becoming a very good source of his livelihood.

As a recently inducted member of the Professional Photographers of America, whose members must be sponsored, Jeffers entered one of that organization's many contests and won. The excerpt below, from a letter from Scott Schwar of the PPA, explains the contest and Mr. Jeffers's citation.

... Congratulations! Your entry in the Great Nostalgia Photo Contests sponsored by Professional Photographers of America, Inc. (PP of A) was selected for publication in a contest review. Both you and your sponsoring photographer will be identified along with your photo. Only fifty entries were selected for this distinction. Although a publication date has not yet been set, when the booklet is published in 1980 you will receive five complimentary copies. Your photograph will be returned at that time.

Over 2500 entries were judged at PP of A Headquarters. The judges included the curator of photography for Harvard University, curator of art for Standard Oil Company, president

of Gamma Photo Labs, an interior designer, and a professional photographer who is an approved national portrait juror for competition judging. There was no pre-selection at the judging. Each judge saw every photograph.

The Great Nostalgia Photo Contest is one of several activities commemorating PP of A's 100th year as an association. The official celebration will be held at our international convention in Atlanta, Georgia, August 9–13, 1980.

Again, on behalf of the PP of A Centennial Committe and its Chairman, Ted Sirlin, congratulations on your winning participation in what proved to be a very interesting judging.

So, there you have it—a complete cycle into professional photography after a career in another field.

There are many more such examples of the use of contests as springboards into careers, but an unusual one is that of Howard Castleberry, who won the $500 third-place scholarship award in the 1979 scholastic/Kodak awards contests while a senior at Lyndon B. Johnson High School in Austin, Texas. His winning portfolio consisted of spot news and sports pictures; it was both impressive and very professional looking.

Castleberry entered the contest on his own, writing away for the entry forms without direction or help from an instructor. Of his interest in photography, he says:

> I've been photographing since I was in the seventh grade (age 13). My junior high school yearbook advisor needed some pictures, and she let me use her 35 mm camera. That was my introduction to photography, and my first experience of seeing my work published, and I've been borrowing cameras and asking questions ever since.
>
> When I was about 15, I got a real good deal on an 8-channel scanner. I started listening to it in the car, with the sole intent of beating the local newspaper to the scene. At the time, they were not known for their speedy spot news coverage, so my getting there first was no real hard task. But I never could get a picture published unless it was very good, because their policy was to run a staffer's pictures first, no matter how bad it was. But since some of the photographers couldn't even get to the scene at all, they eventually published my pictures. I also worked for a

small daily in Austin for about 6 months, but I stopped after they decided not to pay me.

My summer internship at the Dallas *Morning News,* after I won the Scholastic/Kodak scholarship award, was extremely beneficial to me. Not only did I learn a lot about photojournalism and what looks good, but I also learned about how newspapers operate. I was treated as an equal at the *News,* not only on the level of assignments I shot, but in decision-making as well. I learned a lot about how assignments should be treated. I learned about professionalism.

When I found out that I had won one of the top scholarship awards, I felt relieved—relieved that the waiting for the results was finally over. Then I got real happy—you know, a couple of shouts of joy, a few jumps in the air, but nothing real major like breaking down and praising the Lord. Then I wondered what the other two portfolios looked like. If I got third, how good were the other winners? I still haven't seem them.

Prior to this win, I had won several state high school photography awards. In my freshman year, I won every possible photo award in state high school yearbook and newspaper competitions. I did almost as well in my senior year. In my sophomore and junior years, I didn't work for our yearbook or newspaper, not only because I was freelancing a lot, but also because the advisors were very hard to get along with, and I didn't want to deal with their "B.S." I won in the Scholastic/Kodak contest when I was a freshman, too. I won the Award of Excellence for black-and-white photography in the seventh through ninth grades division. There were only two given nationally.

I have never had any formal training in photography except one color printing class that wasn't much of a learning experience at all. The photo courses in our high school were better than most, but that's not saying much. Our darkroom was very well equipped, but the two teachers knew little about photojournalism or just photography in general. . . . More than once I had to correct a teacher in a color printing class.

I am a self-taught photographer, picking other people's brains and learning by trial and error. In my beginning years in photography, I was very fortunate in meeting some patient people who were willing to take time, to show me, to talk to me.

I used the preparation for the Scholastic contest as motivation when shooting pictures. I didn't specifically shoot for the

contest—that is, I didn't try to predict what kind of shots would win and then go out and shoot them. I just shot subjects that were interesting to me and covered them the best way I could. Some people will shoot "contest portfolios" (portfolios that have a certain number of feature angles—something that will jerk a tear, or an off-beat sports pictures) with the sole intent of trying to win the contest. I have never done that, and hopefully, I'll never have to do that. I always try to be as objective as possible when taking pictures, interpreting the situation as it happens. Rather than thinking of what might win in a contest, I think of what picture might best show what the story is—and that is photojournalism.

Personal opinions weigh heavily in judging. Sometimes judging is biased, and that can't be helped. Judges are human, and there are so many variables in judging procedures. But every once in a while, every few years, the right person wins with the right portfolio, and everyone says "Hey, that's nice. He really *is* the Best Photographer of 19--." When that happens, I want to enter contests. But I see decisions that I grossly disagree with. . . . Contests should be plusses, and nothing else. I have never entered a contest, not won, and then been mad about it. That's not the right attitude. One should go into a contest thinking, "No matter what the outcome of the contest, I will still be just as good a photographer." Losing this contest does not mean that I am no good. But winning means that someone (and maybe not everyone) but someone likes my work.

Competing in contests is a good way to start building your portfolio. It is a goal to work for, and when you have a goal and are motivated, you'll go places. If a guy starts the year saying, "I'm going to win College Photographer of the Year," and is determined in his conviction, chances are he'll probably have a better portfolio than someone who isn't motivated. But contests shouldn't be the sole driving force of your motivation. Shooting good pictures should be!

After winning his scholarship award, Castleberry went to the University of Texas in Austin. He is still a photographer, free-lancing as in high school, and also working, photographing, and doing darkroom work for the University of Texas News and Information Services and the University of Texas Yearbook.

Well, now you've met Howard Castleberry—a college student who is also a very serious, hard-working photographer, an attitude he has had since he first picked up a camera at age 13.

Contests are assuredly one of his steppingstones to a career—that, plus talent, good hard thinking, and courage. He sets quite an example for all of us.

CHAPTER 8

Interviews with Some Winners

Contest winners come from all walks of life and with a wide variety of photographic styles. What most of them have in common, aside from a well-developed photographic technique, seems to be the ability to use their skills to express their own personalities and awareness of the world as they see it. As with any art form, photographic self-expression may represent almost any aspect of existence—a feeling for humanity, a love of nature, an appreciation of real or abstract forms. There is no one "right" approach to making contest-winners.

Just as the approach of the individual photographer is different, so is the experience of entering and winning a contest. One photographer may see a contest prize as a step toward commercial success, as another a way of paying overdue bills, a third as a justification of the time and effort spent in mastering a difficult and intricate craft, a fourth simply as a way of proving to him- or herself (or to someone else) that it could be done. The contest-winners interviewed below all had their own approaches and their own styles, and each one derived something different from winning.

LINDA FOARD

When she was a senior at Myers Park High School in Charlotte, North Carolina, Linda Foard won the top prize of $2,000 in the 1979 Kodak/Scholastic Photo Awards Contest for the best portfolio of 12 photographs. Her instructor was Byron Baldwin (see chapter 6), whose students have an outstanding record of winning top awards and citations in this contest.

The judging criteria for the Scholastic/Kodak contest are creativity and camera and darkroom skills, repesented by a portfolio of 12 photographs that each contestant must submit. Foard's portfolio, seen in the exhibit of the 300 winning photos, showed an overall sensitivity and a strong though quiet emotional quality. Her

work displayed a deep feeling of sincerity and reverence for her subjects, and totally omitted any of the obvious "cute" or "POW!" type of pictures. It is gratifying to know that the judges responded to and rewarded this kind of work. In fact, the exhibit's whole level of quality was extraordinary, and it is inspiring to know that our high school students are capable of producing such sensitive, intelligent photographs in all areas of the photographic medium.

Asked at what point she discovered that she could go beyond merely recording what was in front of the lens and actually use the camera as a tool to express her feelings, Foard professed uncertainty. "I don't know," she said. "It just emerged, perhaps because of the kind of assignments that Mr. Baldwin gives, such as 'dark on light,' 'near and far.' The class is always so interesting. There's a large sign in the classroom that says, 'Think light.' It all combines to spur you on, and to stimulate you."

In preparing a portfolio to submit to the contest, she explained:

> I started with one group of photographs, but I wasn't satisfied. I kept taking pictures out and substituting others. I would go out and ride around and take pictures specifically for the portfolio, and so kept eliminating, and adding. The pictures in the final portfolio were all taken within two months of the submission date. There was one 35 mm color, two 35 mm black-and-white, and the rest were taken with a 4 x 5 camera.
>
> My interest in photography has changed the way I view the world. Things I used to overlook now take on new meaning with form, light, and texture. My photographs have become so much a part of me that without them I would feel a great emptiness. A feeling of self-worth and self-achievement emerge when I create a good photograph. I treasure this feeling. The most satisfying times of my life now are when I'm involved with photography.

Foard used the scholarship money to attend Virginia Intermont College because of that institution's many art and photography courses. While in high school, she had become acquainted, through Byron Baldwin, with Virginia Intermont's photography instructor. The high school and college classes had taken some photography field trips together.

Winning a contest, especially one as important as this, is a big event. Foard describes her reaction when she got the news. "I put the letter down, and said to myself, I need to go out and cry. I went out into the woods, and did cry because I just couldn't believe it, and when I came back I told my parents." About becoming a professional photographer, she says, "I don't worry about work, I just want to learn right now."

LEON KUZMANOFF

In 1970, *Life* magazine ran what must have been the biggest photo contest of all time. The prizes were worth more than $80,000. Forty thousand contestants submitted more than 500,000 photographs in the three categories: Landscapes, Faces, and Action. The contest was open to both professionals and amateurs, and the amateur entries outnumbered the professional entries by more than 12 to 1.

The Grand Prize was a $15,000, one-year contract with the magazine. It was won by Leon Kuzmanoff, a New York City advertising photographer. The entire December 25, 1970, double issue was devoted to all the prize-winning photographs, with seven pages given to Kuzmanoff's portfolio of landscapes.

These pictures were from a self-assigned project. Whenever he had free time, Kuzmanoff would go to places he had never visited before, where he would try to capture with his camera whatever revealed itself to him. His goal was to take pictures in every state in the Union. At the time he won, Kuzmanoff still had 41 more states to go to. Now, more than 10 years later, he is still working on the project, and has only one more state to do—Alaska. The one-year contract with *Life* was for continuation of the project, and a year after his winning portfolio was published, the magazine ran a spread of the new pictures he had taken.

In a recent interview about that record win, he recalled his experience. "I felt pretty good. I really got a kick out of taking the pictures. I had gotten into the Americana thing several years before the contest. Of course, these pictures were not taken specifically for the contest. As a matter of fact, it is the only contest I ever entered, before or since. I had been vaguely aware of the contest, but a

friend who knew about my personal project saw the connection and suggested that I enter."

Concerning the effect winning this contest had on his regular work, he feels there was "not that much. But it did put a spotlight on me with my clients. People like to know that you have another nuance."

He describes the on-going project as "an important part of my life. I go off alone to photograph just for myself. I always remember the pictures that I didn't get. But now, all I'm concerned about is that I do the right one, let go, and then go on. I still have a tremendous amount of work on it. There are so many prints to make. But since I am so involved commercially, I get pulled away from it. Sometimes when I'm just getting immersed in the darkroom, I have to do an assignment, so I've decided to build a separate darkroom just for this project."

How gratifying it is to see that through a contest, a body of work to which a photographer is so dedicated can get this kind of recognition. As Kuzmanoff describes it, "It is a soul-saving thing. It's great to do what you believe in, and it came through. Winning the contest proved it was the right thing to do—for me."

JEFF VANUGA

Jeff Vanuga was a first-place winner in the 1979 *National Wildlife* magazine photo contest. His color transparency of raccoons earned him $200 and publication of the photograph in the magazine. He describes here how he came to take the winning photograph and then to enter the contest.

> I am an undergraduate student in Wildlife Science at Utah State University in Logan, Utah. My main photographic interests are wildlife and the environment. Utah State University in Logan, is centrally located within the intermountain West, and I try to take every opportunity to travel and photograph wildlife. When travel is limited because of school or work, I photograph in my own area. Cache Valley (located in the Logan area) and Bear River Refuge are minutes away from home.

My photographic hobby started [about 1972], when I purchased a Minolta SRT-101 with a standard lens. Within a year, I added a 100–200mm Rokkor-X zoom, and became increasingly interested in outdoor photography. My techniques in photography improved along with my studies of the habits and behavior of wildlife. During a trip to Florida with a friend, we canoed down the Weekie Wachie River, where I photographed the winning picture. A camera ready in hand was important, as the racoons were gone as fast as they came, and I could only take two shots of them.

When I saw the results, I had an 8 × 10 color print made, and hung it on my wall. It made a good impression with my friends, and encouragement from them was an incentive to try to get it published. In September of [1979], I sent in three slides to the National Wildlife Photography contest. At that time I needed money badly, since I support myself, besides attending schools.

A little over a month later, I received a Western Union Mailgram, which said, "Please phone *National Wildlife* magazine collect as soon as possible, regarding information about your photo contest entry." My first reaction was that something happened to my slides. After some thought, I figured that I might have won something, and raced to the nearest phone booth to find out what was happening. I learned that I was a semifinalist in the contest, and that additional information was needed for a caption in the magazine.

I was thrilled. I was a semifinalist among 10,000 entrants in the contest. "Not bad," I said to myself. I then went back to my friends to tell them the good news, and to phone my mom to share my feelings with her. A few weeks later, I received a letter from the magazine, "Enclosed is payment of $200 for your First Place prizewinning photograph of the raccoons in the 1979 *National Wildlife* Photo Contest. Congratulations."

I then purchased a new Minolta with the prize money and have spent more time in the field, photographing. I am entering more contests, and building up a file, and also selling pictures on a freelance basis.

Jeff Vanuga is an example of someone with a very specific interest who is applying and developing his photographic skills to enhance his versatility in a particular field.

SHELLEY ROTNER

Shelley Rotner won the top prize, a trip to Russia and Mongolia, in the 1979 *Natural History* magazine contest. Her winning photograph of three little girls in Guatemala, was published, along with the other winning photographs, in the August 1979 issue of the magazine. She had entered three photographs in the contest, all of which were kept for the final judging.

This was the second time she had entered a *Natural History* magazine contest. In the previous contest, one of her three entries had been held for the final judging. Earlier, she had had a photograph accepted for a juried show organized by the Portland (Maine) Museum of Art, entitled "Images of Women."

Although a full-time schoolteacher, Rotner is very active photographically. She has done two photographic projects for the United Nations, children in Ireland and on migrant farm workers in North Carolina. She also covered the Special Olympics for the handicapped in Brockport, New York.

Rotner has been photographing for close to 10 years. While studying photography at Syracuse University, she spent a year living with a family in Holland, and did an independent photographic study of the people and their land.

Heartened by this wonderful first prize, she plans to enter more contests.

KIM ECCLESINE

One photographer who was able to derive some satisfaction out of winning a less-than-satisfactory photo contest is Kim Ecclesine, a San Francisco-based photographer. In a feature article in the July 1979 issue of *Popular Photography,* she published an article entitled "How I Won First Prize. Lost $700 (and Would do it All Over Again)."

The previous year, Ecclesine had entered a contest sponsored by a stock photo house called Photo Talent Associates (PTA). The Grand Prize and First-through Fourth-Prize winners were to have their works displayed at Images, a well-known photographic gallery in New York. In addition, the Grand Prize winner would

receive a Windjammer cruise (departure and destination unspecified) and "a fabulous Nikon FM." Entrance fees totaling as much as $10 were required for a maximum of three photographs submitted.

Ecclesine entered the contest with three 11 × 14 color prints (which cost $17.50 each to produce); she also paid the $10 entry fee plus round-trip postage and insurance. All told, it cost her approximately $70 just to enter the contest.

When she heard she had won the Grand Prize, she was naturally elated and felt that she wanted to see her work exhibited; quite understandably, she had "fantasies" of "a big opening with the press, leaping up several levels of opportunity, not having to scrape anymore."

Believing that she could either cash in or sell the cruise, which she thought must be worth between $500 and $1,000, she booked a round-trip flight from San Francisco to New York. But in New York, she learned several things that she had not considered in her excitement. First, the cruise itself originated in Florida; in order to take it, she would heave to pay her own way to get there. Second, the cruise was worth only $375. Third, the contest sponsors (unlike most reputable sponsors) offered neither a cash equivalent nor a substitute prize. The cruise company refused to cash in the prize, and the sponsors made no attempt to help Ecclesine in her negotiations with the cruise company. (Ecclesine also learned that the Nikon cameras awarded to the first-prize winners were bodies without lenses.)

Since there were no illegalities in the contest's rules, and since the sponsors were quite prepared to live up to the letter (if not the spirit) of their agreement, Ecclesine was forced to admit she had acted on impulse and to absorb all the costs of her trip. Despite the rather expensive object lesson Ecclesine was still pleased enough about winning to write:

> All in all, the prize could have been better, but I still feel highly flattered to have been selected over all the others, and feel that the resulting ego boost gives me the confidence to put my work in front of people, so in a sense this is a spring-board effect. Since that contest, I entered a juried show, and won two awards in it.

The article in *Popular Photography* was an additional boost.

Fortunately there are plenty of good contests, and it is always a thrill to win. Alva L. Dorn tells an amusing story connected to a contest he won.

He won a station wagon, the top prize in the 1960 *US Camera* magazine international black-and-white contest with a picture of five "smiling" kittens. He received the news about the prize from Ed Hannigan, presently dean of the School of Modern Photography in Little Falls, New Jersey, but then editor of *US Camera*. When Hannigan phoned, he insisted that Dorn sit down before he would continue the conversation. He did this because in previous contests some people had fainted when he told them the good news.

CHAPTER 9

Entry Forms

In this chapter are a number of contest entry forms representing many different kinds of photo contests with a wide variety of purposes.

Although you may not be eligible for, or even interested in, some of them, reviewing the requirements should give you some practice in analyzing the forms and knowing what to look for. This practice should be of great assistance when you do plan to enter a contest.

Look for the following information in an entry form:

Subject requirements
Your eligibility
Use of special equipment
Color or black-and-white, or both
Size and number of entries
Information required on the entries, including releases
Entry fees
Sponsors' use of winning pictures (and any other pictures), including rights requested
Provisions for return of entries
Deadline for submitting pictures
Date winners will be announced
Nature and number of prizes

Being able to see so many contest forms grouped together will give you the opportunity to compare them and see how they both differ from and resemble one another.

Some of these forms are for one-time contests that have already taken place, but similar ones keep coming along. Other forms are for contests that are given on a regular basis. **None of the forms presented here should be used for entering current contests;** names and addresses of the contest sponsors are listed after each form so you can write to request the most recent and up-to-date information on recurring contests.

Besides the contests presented in this chapter, several have been featured earlier in this book. See the chapters listed for the forms on those contests.

Natural History magazine contest—chapter 2
National Bowling Council contest—chapter 2
New York magazine contest—chapter 2
Knott's Picture Your Kid Photo Contest—chapter 3. (This contest offers excellent prizes, but you have to go to Knott's Berry Farm in California to take the pictures.)
Work and Leisure International Photo Contest—chapter 3

In addition to the forms listed above, some information is also provided in the text on the following contests:

Pictures of the Year (POY)—chapter 2
Kodak International Newspaper Snapshot Awards contest (KINSA)—chapter 4
Campfire Girls National Photo Contest—chapter 5

NIKON PHOTO CONTEST INTERNATIONAL

Comments Annual contest, open to everyone.

This contest, open to both amateurs and professionals, accepts both black-and-white and color photographs.

Of the many entries, 142 winning photographs are chosen. These winners become part of a traveling exhibition and are published in the Nikon Photo Contest International Annual. A copy of the Annual is sent to every contest entrant, winner or loser.

For latest information and entry form, write to:

Nikon Photo Contest International
Nikon, Inc.
P.O. Box 307
Garden City, NY 11530

NIKON INTERNATIONAL PHOTO CONTEST

ENTRY RULES

1. The Nikon Photo Contest International (NPCI) is open for entry to any photographer, professional or amateur, from any part of the world, except residents of Japan.

2. Any subject matter is acceptable (see Note at the end of "Entry Rules").

3. Only photographs taken with a 35mm camera such as the Nikon may be accepted as entries, provided they conform to Rule No. 4.

4. Published photographs or those that have either been accepted or are presently submitted for publication are not eligible. In the event an award-winning photograph is later found out to have violated this rule. Nippon Kogadu K.K. reserves the right to take any action it may deem suitable, including the return of the prize or prizes awarded. Also, the winning position will be voided.

5. You may submit a maximum of five entries for each of the contest's two categories provided they are accompanied by a properly completed entry form.

Black-and-White Category (Category A)

Entries must be unmounted black-and-white prints, enlarged from the original negative to a minimum of 20cm x 25cm (8 in. x 10 in.) and a maximum of 28cm x 36cm (11 in. x 14 in.). Indicate on the back of each print, preferably in block letters, the following: *(1) the entry number assigned, (2) your name, (3) your address, (4) the name of the country in which you enter the contest, and (5) the title of the photograph.*

Color Category (Category B)

Entries acceptable in this category can either be color slides mounted in the standard paper mount, or unmounted color prints.

Glass mounts are not recommended as they may break in transit and damage your works.

All slides must have the required indications (see illustration) on the desired side for viewing.

All unmounted color prints must be enlarged to a minimum of 20cm x 25 cm (8 in. x 10 in.) and a maximum of 28cm x 36cm (11

in. x 14 in.). On the back of each print must be indicated, prefera-
bly in block letters, the following: *(1) the entry number assigned,
(2) your name, (3) your address, (4) the name of the country in
which you enter the contest, and (5) the title of the photograph.*
6. All entries must reach the Nikon distributor in your country
not later than [date]. For information on the name and address
of the distributor, consult your nearest Nikon dealer. Entries sent
directly to Nippon Kogaku K.K. will be ruled ineligible for the
contest.
7. All entries will be judged by a panel of judges appointed by
Nippon Kogaku K.K.; the judges' decision will be final.
8. The judging will take place in [date]. All winners will be noti-
fied individually through the corresponding Nikon distributor.
9. All the winning photographs will be published in the Nikon
Photo Contest International Annual [year]. A copy of the annual
will be sent to each entrant who fills in the Nikon Photo Contest
International Annual Form that appears with the entry forms.
10. Winners will be required to submit the original negatives or
color slides—not copies—of the winning photographs before the
prizes are awarded. Failure to comply with this rule may result in
disqualification. The winners' original negatives will be returned
to them after verfication of their originality.
11. Prizes will be awarded to winning entries by Nippon Kogaku
K.K. through the Nikon distributors to whom the entries were
submitted.
12. Nippon Kogaku K.K. will not be responsible for any claims
or complaints from models used in winning photographs should
these photographs be published or exhibited. Such responsibility
will be deemed to be the entrant's. If necessary, Nippon Kogaku
K.K. may request the entrant concerned to submit a model-re-
lease statement before the prize is awarded.
13. Nippon Kogaku K.K. reserves all rights to the reproduction,
publication and exhibition of all winning photographs.
14. All black-and-white prints and color prints submitted, both
winners and non-winners alike, will not be returned to their en-
trants. Non-winning color slides, however, will be returned at the
expense of Nippon Kogaku K.K. to entrants who fill in the Color
Slides Return Form that appears with the entry forms.
15. Winning color slides will be returned after the Annual is
printed.
16. While all possible care will be taken in handling all the en-

tries, Nippon Kogaku K.K. and Nikon distributors will not assume any responsibility for their loss or damage in transit.

17. Failure to comply with all the preceding rules and regulations may disqualify any entry and lead Nippon Kogaku K.K. to take any action it deems fit.

A letter of inquiry about Rule 13 brought the following response: "Nikon does provide monetary compensation for this consideration, dependent upon intended usage of the photograph." Also attached was a legal agreement that indicates that Nikon will pay for certain stated uses of the photographs, such as: "Nikon's own catalogs, sales brochures, show cards, posters and similar publications or to display such photograph at photographic or other trade fairs held or sponsored by Nikon. . . ." The agreement continued: "In consideration of the rights mentioned . . . above, NIKON will pay the Photographer, the sum of US$———. NIKON will pay the Photographer an additional amount of US$——— if and when the photograph is definitely earmarked for use in——— [publication]."

Note

All photographs rejected by Japanese Customs officials will be returned directly to the distributor by the officials. (Generally, nude photographs showing pubic hair, regardless of aesthetic qualities, are not allowed to enter Japan.)

Awards & Prizes

1st Prize (one winner in each category)
Gold medal with winner's name engraved, and the following prizes—

Camera body Choice of Nikon F2 or Nikon F2A Photomic

Accessories Set of Motor Drive MD-2 and Cordless Battery Pack MB-1.

Lenses Two Nikkor lenses, one each from Tables 1 and 2

2nd Prize (10 winners in each category)
Silver medal with winner's name engraved, and the following prizes—

Camera body Nikon FE

Lens One Nikkor lens listed in Table 1

3rd Prize (20 winners in each category)
Bronze medal with winner's name engraved, and Nikon FM camera body

Honorable Mention (40 winners in each category)
Bronze medal with winner's name engraved, and a special gift
Nikkor Lens Table 1
20mm f/3.5·24mm f/2.8mm f/2.8
28mm f/3.5·35mm f/2·35mm f/2.8
35mm f/2.8 PC·50mm f/1.4·50mm f/1.8
50mm f/1.2·55mm f/3.5 Micro·85mm f/2
105mm f/2.5·135mm f/2.8·135mm f/3.5
200mm f/4·43—86mm f/3.5 Zoom
Nikkor Lens Table 2
16mm f/3.5 Fisheye·18mm f/4·24mm f/2
28mm f/2·35mm f/1.4·105mm f/4 Micro
135mm f/2·180mm f/2.8·
200mm f/4 IF Micro·300mm f/4.5
500mm f/8 Reflex·28—45mm f/4.5 Zoom
35—70mm f/3.5 Zoom
80—200mm f/4.5 Zoom

ADDENDA TO RULES

General
The entry number, quantity and type of photos (Black-and-White or Color), (Prints or Slides), MUST be indicated on the lower left-hand corner of the envelope.
Receipt of entries will be acknowledged if you provide a stamped, self addressed *POSTCARD.*
The Photo Annual will be mailed in August.
Rule 14
Rejected Black-and-White and Color Prints will be returned if Entrant:
1) Encloses a stamped, self-addressed envelope.
2) Writes entry number and number of prints (Black-and-White or Color) on the lower left corner of the return envelope.
Prizes Available
Winners may substitute prizes listed for Nikon lenses or accessories on an equal retail value basis.

NIKON PHOTOMICRO/MACROGRAPHY CONTEST

Comments. Annual contest, open to everyone.

Entries in this contest are limited to 35mm mounted color transparencies taken with specific lenses (all information is spelled out

in the entry form). Prizes are excellent, and the winners also get a 16 x 20 color print. Also note that prizewinning photographs are exhibited.

For latest information and entry from, write to:
Nikon's Small World Competition
Nikon Instrument Division/EPOI
623 Stewart Avenue
Garden City, NY 11530

NIKON PHOTOMICRO/MACROGRAPHY CONTEST

1. This competition is open to everyone interested in scientific photography. Anyone is eligible, with the exception of employes of Ehrenreich Photo-Optical Industries, their families, and individuals engaged in the manufacture or sale of Nikon products.
2. Color photomicrographs and photomacrographs in 35-mm mounted *transparency* format only will be accepted. *Do not submit prints.*
3. Photomicrographs and photomacrographs taken with 35-mm cameras such as the Nikon series of compound microscopes; and photomacrographic equipment, such as the Nikon Multiphot, are eligible.
4. Magnification range must fall between 20X and 2,000X.
5. All techniques are acceptable. (Phase contrast, polarized light, fluorescence, darkfield, interference, reflected light, etc.)
6. The subject matter is unrestricted. Any type of specimen is acceptable. In order to be eligible, a brief description of the specimen, the microscope and camera equipment, technique used, and objective lens must accompany each transparency. No more than three entries permitted per individual. The official entry form should be used.
7. Entries will be judged on:
 A. Informational content
 B. Composition
 C. Color balance
 D. Color contrast
 E. Originality

8. Nikon Instrument Division's panel of judges reserves the right to be the final judge of entries. All winning entries become the property of the Nikon Instrument Division and cannot be returned. Non-winning entries will be returned if a stamped, self-addressed envelope is submitted.
9. Entries will be accepted until [date]. Entries must be postmarked by that date to be eligible for prizes.
10. Winning entries will be exhibited at Nikon House in New York City, and the first twenty prize winners will receive a 16x20 in. color print of their award-winning entries.

1st prize—Air travel and hotel accommodations to be arranged by us for a vacation trip up to a value of $1,000 or if the winner does not desire a vacation trip, the difference up to $1,000 may be taken in Nikon photographic equipment, or Nikon scientific or industrial instruments or accessories, all at their suggested retail selling prices. In addition, the winner will be given an all-expense paid round trip to New York City for the award presentation. (Limited to winner residing in continental U.S.)

2nd prize—A Nikon F2 camera with a 50-mm f/2 lens, with carrying case.

3rd prize—A Nikkormat FT3 camera with a 50-mm f/2 lens, with carrying case.

4th, 5th, 6th prizes—Nikon 7x21 compact binoculars.

7th, 8th, 9th, 10th prizes—Nikon 3X Sports Glass binoculars.

11th-20th prizes—A 16x20 in. color print of entry.

21st-40th prizes—An award certificate for the entry.

Please make certain that your name and address accompany your entry and appear on each transparency submitted.

NATIONAL WILDLIFE MAGAZINE CONTEST

Comments. Annual contest, open to everyone.

The contest accepts color photographs only.

The top prize of this contest is a trip, for which there is no cash equivalent if the winner does not take the trip. The total amount of prize money is $2,000, but the number of prizes and the amount each winner gets is not specified. A letter of inquiry about these points brought the following reply:

The $2,000 is divided in accordance with the play [in the magazine] each winning photo receives. If we use 10 photos, the one on the cover gets more than the smallest inside use, etc. There are no hard guidelines.... Everyone published receives some money down to the minimum of $100.... I would think that the grand prize winner is entitled to the trip, but no equal money compensation if he cannot make or does not want to make the trip.

Jeff Vanuga (see chapter 8), a student of wildlife science at Utah State University, received $200 for his winning photograph. Reading about his experience in this contest shows how very much it encouraged him to pursue his specialty in nature photography. One cannot deny that the purpose of *National Wildlife* magazine, which is published by the National Wildlife Foundation, is worthwhile, dedicated as it is "to the wise use of our world resources."

For latest information and entry forms, write to:
Photo Contest
National Wildlife
225 East Michigan Street
Milwaukee, WI 53202

NATIONAL WILDLIFE MAGAZINE CONTEST

GENERAL INFORMATION

A total of $2,000 in prizes will be awarded, and all winners will be displayed in the April-May, [year], issue of NATIONAL WILDLIFE. Grand prize: a trip for two to a National Wildlife Federation Conservation Summit in the Blue Ridge, Adirondack or Rocky Mountains.

The theme is as big as all outdoors: Nature in America. Whether you prefer taking pictures of wildlife, plants, scenery or people participating in outdoor activities, your photographs are eligible. The only requirements: all photos submitted must be taken within the U.S., and all plants or animals depicted must be indigenous to this country.

SUBMISSIONS

All entries should be in color. Write your name, address and telephone number on each submission, and send a self-addressed, stamped envelope. With each entry, also include the make and model of camera and lens used, the exposure setting, and a brief description of where, when and how it was taken. Limit your entry to five photos. Prints up to 8x10 inches are acceptable, but slides are preferred. Winners will be chosen on the basis of originality and execution. All entries will be returned by [date]. Deadline is [date].

AMERICAN VISION CONTEST

Comments. Annual contest, open to everyone.

The best explanation of this competition is the statement made at the exhibit sale that took place following the first *American Vision* competition in 1979:

> *American Vision* is the first nationwide juried photography exhibition organized by the National Artists' Alliance. Open to all American photographers its purpose is to provide photographers from all over the country an opportunity to exhibit their work in New York City.
>
> From over six thousand photographs submitted two hundred and seventy two pictures were chosen for exhibition. Five thousand dollars was awarded among thirty-four of the photographers represented.
>
> *American Vision* has been designed to emphasize photography as an art. The pictures in this installation are not categorized. The image takes precedence.
>
> *American Vision* presents the art of American contemporary photography at its best. We hope the exhibition will be a rewarding experience for you.
>
> Photographs exhibited are for sale. For information contact Gallery Manager. (The National Artists' Alliance collects no commissions or fees on any photographs sold.)

This contest had a judging panel (referred to as a jury) of 12 well-known people in the field of photography (see chapter 5 for interviews with several of these individuals). The reason for this large panel was to be sure to cover all expressions of photography, which was to be the purpose of the exhibition itself. The jurors were: Ken Heyman, well-known American photographer; John Loengard, an internationally noted photographer and picture editor; Cusie Pfeifer, director of the Marcuse Pfeifer Gallery in New York City; Arthur Goldsmith, editor of *Popular Photography*; Maude Shuyler, associate director of Light Gallery in New York City; Ben Fernandez, chairman of the Photography Department at the New School for Social Research in New York City; Sean Callahan, editor of *American Photographer*; Monica Cipnic, picture editor for *Popular Photography*; Gene Thornton, *New York Times* photography critic and contributing editor to *Art News*; Arnold Drapkin, *Time* magazine picture editor; Willard Clark, editor-in-chief of *Camera 35 Photo World*; and William Ewing, director of exhibitions for the International Center of Photography in New York City.

For latest information and entry forms, write to:
Mr. Gene Healey
National Artists' Alliance, Inc.
P.O. Box 1662
New Haven, CT 06507

AMERICAN VISION/NATIONAL ARTISTS' ALLIANCE CONTEST

GENERAL INFORMATION

All photographers (fine art, journalistic, commercial, amateur) are invited to participate in the National Artists' Alliance first nationwide juried photography exhibition, *American Vision*, opening at New York University's 80 Washington Square East Galleries, New York City (all six galleries), [date].

HOW TO ENTER

We will be accepting photographs between now and [date]. Entrants must submit a minimum of *two (2) unframed* photographs. Your entries may be two unframed black and white or color prints, or two 35mm slides. Any combination of the above may be submitted. Prints may be loose; they do not have to be matted or mounted. Prints should not exceed 11 x 14 inches. NO ENTRY FORMS ARE NEEDED.

MAIL YOUR ENTRIES TO: NATIONAL ARTISTS' ALLIANCE, P.O. BOX 1662, NEW HAVEN, CONNECTICUT 06507. PRINT YOUR NAME, ADDRESS, PHONE NUMBER, TITLE OF PHOTO AND PRICE (if you wish to sell your photo) ON THE BACK OF ALL PRINTS AND SLIDES. A RETURN ADDRESSED PACKAGE/ENVELOPE (the same size of print) AND CORRECT RETURN POSTAGE MUST ACCOMPANY ALL ENTRIES. IF YOU WISH YOUR PHOTO RETURNED IN THE SAME PACKAGE IT WAS SENT IN PLEASE INCLUDE CORRECT POSTAGE. Please do not mail photographs in wooden crates.

ENTRY FEE

A check or money order for ten dollars ($10.) must be included with your initial two entries. Additional entries are five dollars ($5.) each with no limit on the number of photographs entered. Please make checks payable to: NATIONAL ARTISTS' ALLIANCE Inc.

GENERAL INFORMATION

The National Artists' Alliance is an organization dedicated to the promotion of all visual artists. Funds generated by this exhibition will be utilized to establish a non profit agency devoted to the advancement of artists who choose to participate in events sponsored by the National Artists' Alliance. No commissions will be charged on any photographs sold during the **AMERICAN VISION** exhibition. This is a rare opportunity for photographers from all over the country to exhibit their photographs in New York City. Your participation in this show is essential. Our resources are limited. If you do not wish to enter the exhibition please give other photographers a chance by telling them about it. We need your help. We are trying to accommodate every pho-

tographer by making it as simple as possible to enter and by allowing the most time for all photographers to enter their work. We expect this to be the most prestigious exhibition of its kind to date.

 AMERICAN VISION will be juried in [date]. Award winners and exhibitors will be notified immediately. Instruction concerning accepted slides will be mailed individually and immediately after jurying. *Work not accepted will be mailed back to photographers following jurying.* Information relating to exhibition installation will be sent to all photographers exhibiting in the **AMERICAN VISION** show. Entries will be handled with all possible care. Neither the National Artists' Alliance nor New York University can be responsible for loss or damage from any cause. Any envelope/package received damaged will be returned unopened. To date no art object has ever been damaged or lost in an event sponsored by the National Artists' Alliance. We mean to keep it that way. Entry fees are not refundable. The decision of the jurors is final.

AWARDS

$5000 in cash prizes. $2000 National Artists' Alliance Award. $3000 in additional cash prizes.

PORTER'S CAMERA STORE BLACK-AND-WHITE PRINT CONTEST

Comments. Was held annually; was open to everyone, black-and-white prints only.

 Porter's Camera Store of Cedar Falls, Iowa, which has a very large mailorder department, ran this contest every year. While it was obviously a promotional device for black-and-white printing papers, and for Porter's catalog itself, the contest was quite reputable and well established. The six top winners had their photos published in the catalog and received $50 each. Every entrant received a gift, a certificate, and a catalog; the catalog itself is full of information, illustrations, and listings of a vast number of major and minor items applying to photography, many of which are never

available in the average camera store. Some of these items are quite idea-provoking.

Photographs were not returned. It is hoped that this contest will be reinstated.

The following were the rules and awards for this contest.

PORTER'S CAMERA STORE
ANNUAL BLACK & WHITE PRINT CONTEST

GENERAL INFORMATION

We are continuing our **B&W** Print Contest. The Contest is being expanded to accept entries made with Kodak, Ilford or Unicolor **B&W** print papers as well as Agfa papers. (The Contest previously was limited to prints made on Agfa papers.) We think the darkroom enthusiast is better served by allowing this freedom of choice from among several fine quality print papers. This choice allows full freedom of photographic expression and paper selection to reflect the user's preference.

We hope you will enter. Every person entering receives a FREE GIFT. Every person entering receives a "Certificate of Photographic Achievement."

RULES

1. Submit your entry on any Kodak, Ilford, Unicolor or Agfa black & white print paper, (not necessarily purchased from us).
2. Submit 8x10″ size only and unmounted please. Do not send negatives and do not send color prints. Entries will not be returned.
3. Contest opens [date] and contest closes [date]. Winners will be notified [date].
4. Categories are—Scenic; Glamour; Human Interest; Sports; Architecture; & Open.
5. The criteria used in judging will be—Aptness to theme or category; technical quality; originality; interest.
6. No limit on where entries can come from. We will accept entries from all 50 states, APO, FPO addresses, Canada and other foreign countries. (No employees of Porter's Camera Store, Inc. can enter).

7. Contest will be independently judged.
8. Send your entries to Porter's B&W Print Contest, Box 628, Cedar Falls, Iowa 50613.
9. Put your name & address and zip code on the back of the enlargement.
10. Put the category you are entering on the back of each enlargement. If you do not specify on the enlargement it will automatically go into a category of our determination.
11. Put the brand, surface and contrast of the paper used on the back of each entry (Example: Kodak Medalist, G surface, Contrast #3).
12. You may enter as often as you like in as many categories as you wish.

AWARDS

1. Everyone entering receives a free gift immediately.
2. Everyone entering receives immediately an attractive "Certificate of Photographic Achievement" (suitable for framing).
3. The "First Place" winning entry in each of the six categories, will receive a check for $50.00, plus a "Certificate of Photographic Excellence."
4. "First Place" winning enlargements in each category will be published in our "K-26" catalog [date] with the winners' names shown beneath the picture.
5. There will also be fifteen "First Runnerup" winners in each of the six categories (total 90). Each of these 90 "First Runner-up" winners will receive a small merchandise award, plus a "Certificate of Outstanding Photographic Achievement."
6. The 90 "First Runner-up" winners will be listed by name and address in our "K-26" catalog.

OCEANS PHOTOGRAPHIC COMPETITION

Comments. Biannual contest, open to everyone. Color only.

Oceans is a magazine published by the Oceanic Society. The entry form explains everything clearly: how to submit entries, in-

formation to be affixed to photographs, how to guarantee return of the entries, number and amount of prizes, when the winning entries will be announced. Winning photographs are published in one of the issues of *Oceans.* There is an entry fee of $5 per category and up to 3 photographs may be submitted in each of the two categories.
For latest information and entry forms, write to:

Oceans Photographic Competition
Fort Mason
San Francisco, CA 94123

THE *OCEANS* PHOTOGRAPHIC COMPETITION

GENERAL INFORMATION

Once again, *Oceans* offers everyone an opportunity to be published in its second photographic competition. There are two general categories:

1. Underwater.

2. The Sea, which will include all marine-related subjects above the surface. There need be no water in sight.

RULES

1. The competition is open to everyone except employees of the Oceanic Society and their kin.

2. All entries, either transparencies or prints, should be in color.

3. Competitors may submit up to three previously unpublished entries in each category. Decision of the judges is final.

4. A label bearing the name and address of the photographer and the category must be affixed to each entry.

5. For every entry, include the camera model used, plus details as to exposure, lens, etc., if possible.

6. Enclose a self-addressed, stamped envelope for the return of entries.

7. The Oceanic Society acquires the right to publish and exhibit the winning photographs and to use them for promotional purposes. The Oceanic Society assumes no responsibility for transparencies or prints.

8. There is an entry fee of $5.00 per category.

9. All entries must be postmarked no later than [date).

First prize for each category is $250. Ten Honorable Mentions will receive $50 each.

All winning entries will be published in the January/February [year] issue.

Pack your slides carefully (slides travel best in plastic sleeves).

NIKON/NUTSHELL CONTEST

Comments. Annual contest, open to high school and college students and faculty only.

Nutshell, the joint sponsor of this contest with Nikon, is a magazine that is distributed annually on college campuses across the United States. Winning photographs are published in the edition for the year in which the contest is held.

A subcategory of this contest is the Nikon/Datsun Travel Photography category for travel-oriented photographs. Entries are elibible to win in both competitions.

Cash awards are given in the Nikon/Datsun category only; all other awards are equipment worth varying amounts.

For latest information and entry forms, write to:

Nikon/Nutshell Photo Contest
P.O. Box 15004
Knoxville, TN 37902

NIKON/NUTSHELL PHOTO CONTEST

GENERAL INFORMATION

For the past years, Nikon has been sponsoring the largest student photography contest in the country in order to recognize excellence in photography by students and faculty. Over 136,000 entries have been submitted and over 1,400 individuals have won prizes. It's an easy contest to enter, and there are many prizes.

First, don't worry about what sort of photos to enter. They can be black & white, color prints, transparencies or any combination.

Second, there's no limit to the number of entries. Just pick out your best and send them all. You're not restricted to a theme either.

Third, if you're into travel photography, note the information on our special travel photography category.

Fourth, if you win one of the top three prizes, your photo will be published in the [year] edition of *Nutshell* magazine read by over two-and-a-half million college students across the country.

Fifth, here are the rules.

ENTRY RULES

1. Contest is open to *amateur* student and faculty entrants only. If you're a full-time professional photographer, an employee of Nikon, its participating dealers, or 13-30 Corporation, you are not eligible to enter or win.
2. Entries from students will be judged only against entries from other students. Faculty members compete with other faculty.
3. Send in as many black & white and/or color entries as you like. (What can you lose?) Both color prints and transparencies will be accepted. Be sure to include an official blank.
4. Submit entries anytime between [date] and [date].
5. Give us a break, please. Send only 8 x 10-inch prints (maximum), 5 x 7-inch prints (minimum) or any size in between. In return, we won't ask you to mount entries. Color transparencies can be in any size from 110 to 2½ x 2¾ inches, but must be encased in standard photofinishing mounts.
6. An independent panel of judges will select the winners on the basis of composition, creativity and overall technical quality. Good points to keep in mind!
7. 13-30 Corporation and Nikon reserve the right to publish prize-winning photos and other relevant entries in their publications and other advertising promotion. At all times, proper credit will be given.
8. We promise to return all non-winning entries if you include a stamped, self-addressed envelope with your permanent address. But please don't expect them back until after [date]. That's when winners will be announced. And, by the way, it's tough trying to fit an 8 x 10 into a letter envelope, so

please make sure your return envelope fits the pictures you send!

9. Be prepared to provide a model release in case we publish or exhibit your photos.
10. Of course we'll treat each entry gently, but we can't be liable for loss or damage. So we strongly suggest keeping a duplicate of your entries. Besides, you might need it before the contest ends.
11. Contest is subject to all local, state and federal regulations. Void where prohibited by law.

PRIZES WORTH $11,250

STUDENT COMPETITION (Prizes will be awarded in two categories—black & white and color)
1st PRIZE $1,500 in Nikon Equipment
2nd PRIZE $1,000 in Nikon Equipment
3rd PRIZE $750 in Nikon Equipment
4th PRIZE $50 in cash (15 winners in each category)
And 100 Honorable Mention award certificates
FACULTY COMPETITION (One category only, black & white and/or color)
1st PRIZE $1,500 in Nikon Equipment
2nd PRIZE $1,000 in Nikon Equipment
3rd PRIZE $750 in Nikon Equipment
And 10 Honorable Mention award certrificates

THE NIKON/DATSUN TRAVEL PHOTOGRAPHY CATEGORY

If any of the photos you submit are travel-oriented, they will automatically be entered in the Nikon/Datsun Travel Photography Category, in addition to the Nikon/Nutshell Photo Contest. Datsun, who sponsors the largest student travel magazine (*America: The Datsun Student Travel Guide*) has teamed up with Nikon to sponsor this special category. There will be five winners, all of whom will be published in a special gallery in *America* and receive $100 cash awards. In addition to this, you can still be a winner in the general contest qualifying for the prizes offered there.

TUCSON FILM COMMISSION LOCATION PHOTO CONTEST

Comments. One-time contest only, open to everyone.

This contest is typical of local competitions run periodically by various municipal and public-service organizations as community service projects. In this instance, the Tucson Film Commission, which is attached to the Mayor's office, wanted to create a picture file showing locations in the city and surrounding areas that might be suitable for film and TV locations. Because the Commission wanted many more photographs than the three winning ones, it paid $5 each for additional negatives, which it acquired permanently. In this case, the permanent acquisition of negatives is understandable, as they are not intended for advertising, resale, or other profit-making uses.

A contest such as this can be applied to many community improvement goals, so keep your ears and eyes open in your own area. You might even consider starting a similar joint community photo contest in your own locality, possibly to publicize the need for a park, a recreational or art center, or any one of numerous other possibilities. The letter below from the Tucson Film Commission explains how their contest worked, and should give you some ideas.

The Community Relations Office which serves as marketing/staff support for the Commission came up with the idea of a photo contest. An earlier citywide photo contest (topic: The Desert In Bloom and The Desert Sun) met with tremendous success and showed the degree of photographic talent in our community. The movie business by its very nature always attracts a high level of community interest; which we combined with this photographic talent.

The judges were members of the Tucson Film Commission.

We plan to use the accepted photographs in a film location file, which will be tapped to meet the various needs of the movie makers who call us for information.

The results of the contest were cash prizes going out to 27 winners. One person won $170 by placing third for a $50 cash

prize and having 24 negatives chosen at $5 each! The total cash awarded in the contest was $1,065.

The final number of entries surpassed 200. The photographers were a varied group; students, one professional, persons who work in photographic supply stores, retirees, persons fond of horseback riding, property owners who would like to have their land filmed, a man visiting from New York who provided some great shots of downtown Tucson.

Subject matter was largely landscape; and some interesting structures and buildings.

Indeed the best part of this contest was a strong sense of community participation. The contest not only gave people an outlet for their photographic talents; but also gave the TFC valuable information about interesting locations and property owners who are eager for a production crew—a combination not always found easily.

We just got word that the photo contest campaign won an Award of Merit in the 1979 City Hall Public Information Awards competition—public information division. The contest was sponsored by the City Hall Digest a publication of the International City Managers Association.

The entry form read:

WANTED: FILM LOCATION PHOTO SCOUTS

general information

These photos may include, but are not limited to: shots of clubs, meeting halls, residences or any buildings with interesting interiors or facades (like the courthouse scenes used in the "Petrocelli" series), valleys, plains, ranches, riverbeds, guest ranches, weathered buildings, etc.

PRIZES

After all your material is in, the Tucson Film Commission will award a first prize of $150, a second prize of $100 and a third prize of $50 to those contributors who show the greatest scope, range of subjects and grasp of "locating locations." So grab your cameras now and help us explore the great film potentials of this fascinating area. For details call the Tucson Film Commission at 791-4000.

ILFOSPEED £1,000 PRINT COMPETITION

Comments. One-time contest only, open to everyone; black-and-white prints only.

Ilford, the British manufacturer of photographic printing papers, ran this contest to bring attention to two new products they were introducing to the public. All prints had to be printed, obviously, on the featured papers. The negatives of the winning entries had to be given to the sponsor (see rule 5, below), but at least the reasons were very clearly stated; additionally, the prize money was very big (note prizes are stated in pounds sterling).

THE ILFOSPEED® £1,000 PRINT COMPETITION.

THREE CATEGORIES & 100 PRIZES

Category 1—is open to all professional photographers (those with half or more of total income from photography)
Category 2—is open to all amateur photographers (those with less than half of total income from photography)
Category 3—is open to all student photographers (both high school and college students)
100 prizes will be awarded to celebrate the fact that 1979 is Ilford's 100th Anniversary. In addition, each winner and runner-up will receive a handsome certificate.
Best of Competition Award—with the winner receiving the Ilford Best of Competition trophy and £1,000 British Sterling ($2,250 at current exchange rates).
Three Best of Category Awards—with winners receiving £500 each.
Nine Awards of Distinction—with winners receiving £100 each.
Eighty-Seven Awards of Merit—with winners receiving 100 sheets of their choice of ILFOSPEED OR ILFOSPEED MULTIGRADE paper . . . 8x10-inch or equivalent.
The work of the top winners will appear in a special exhibition and will also be publicized in both the photographic and consumer press.

Competition Rules

1. All print entries must be printed on ILFOSPEED graded RC paper or on ILFOSPEED MULTISPEED variable contrast RC paper.

2. Prints should be submitted unmounted on 8x10-inch paper, with a fully completed Official Entry Blank attached to the back of each print. Entrants may submit as many prints as they wish, and enter as often as they wish, but each print must have a separate, fully completed Entry Blank attached to it.

3. No negative should be submitted with prints. No prints will be returned.

4. Entries will be judged on photographic excellence, on the originality in the choice and treatment of the subject, and on the quality of the print itself. The decision of the judges will be final.

5. Before receiving a final prize, winners must provide Ilford with the negative for their winning entry; assign unlimited, publicity, promotion and advertising; and provide Iford with a copy of a model release if required.

6. The competition is open to everyone except employees of Ilford, their advertising agency, agents and representatives ... and their families.

7. All entries must be postmarked by [date]. All winners will be notified by [date].

OFFICIAL ENTRY BLANK ILFOSPEED® £1,000 PRINT COMPETITION

Attach to the back of your unmounted 8x10-inch print entry and mail to: ILFOSPEED £1,000 Competition, c/o Ilford Inc., West 70 Century Road, Paramus, N.J. 07652

Complete all of the following

1. Judging Category—(Indicate one which best describes your status)
 ☐ Professional Photographer (principal source of income)
 ☐ Amateur Photographer
 ☐ Student Photographer (attending accredited school)

2. Technical Data—
 Paper used ☐ ILFOSPEED
 ☐ ILFOSPEED MULTIGRADE
 Film used:_____
3. Entrant Information—Please Print
 Address_____
 City_____
 State_____Zip_____
 Ilford Dealer_____City_____
4. And for Statistical Purposes, may we ask you?
 a. Had you used ILFOSPEED/ILFOSPEED MULTI-
 GRADE before?
 ☐ Yes ☐ No
 b. Paper usually used: _____
 c. Total number of prints made per year: _____
 d. What do you like best about ILFOSPEED/ILFOSPEED
 MULTIGRADE?
 Check all that apply.
 ____Richer blacks ____Even grade spacing
 ____Whiter whites ____Fast processing
 ____Tonal range ____Developmental control
 ____Pearl surface ____Back accepts writing
 ____Lies flatter ____Other_____
 e. Do you plan to use ILFOSPEED/ILFOSPEED MULTI-
 GRADE in the future?_____

OMAHA DISTRICT CORP. OF ENGINEERS' PHOTOGRAPHY CONTEST

Comments. Annual contest, open to everyone; photos limited to specific geographical areas.

The U.S. Army Corps of Engineers runs annual photo contests in various localities. No money awards are given, just certificates; note that the Corps "reserves the right to use any photograph or slide entered in the contest either in publications, displays, or slide presentations."

OMAHA DISTRICT CORP. OF ENGINEERS' PHOTOGRAPHY CONTEST

GENERAL INFORMATION

Photographers visiting any of the Corps of Engineers lakes and projects this year within the Corps' Omaha District might want to consider trying their talents at securing shots to submit to the District's annual photo contest.

The contest, which has been restricted to Corps' employees in previous years, is being opened to the general public—professionals and amateurs alike.

The Omaha District's water resource boundary covers the upper Missouri River Basin which includes such lakes as the mainstem dams on the Missouri River (Fort Peck near Glasgow, Mont.; Garrison near Riverdale, N.D.; Oahe near Pierre, S.D.; Big Bend near Chamberlain, S.D.; Fort Randall near Lake Andes, S.D.; and Gavins Point near Yankton, S.D.); the Papio Lake sites in Omaha, Neb.; Chatfield, Cherry Creek and Bear Creek Lakes in or near Denver, Colo.; Salt Creek Lakes in Lincoln, Neb.; Pipestem Lake near Jamestown, N.D.; Bowman Haley Lake near Bowman, N.D. and Cottonwood Springs and Coldbrook Lakes near Hot Springs, S.D.

The Corps. says more than 15.4 million visitor days were logged at these lakes last year and that photography ranks high on the list of activities which visitors engage in.

First, second and third place winners will be selected from color print, black and white, and color slide entries in the following categories: Omaha District Projects, Wildlife, Flora, Recreation at District Projects, District Employees on the Job, and Human Interest.

A Sweepstakes Award will be given for the photograph or slide selected as the best of all the entries.

Winners will receive certificates, and the Corps reserves the right to use any photograph or slide entered in the contest either in publications, displays, or slide presentations.

Staff members from the Omaha World-Herald and Creighton University have agreed to serve as contest judges.

CONTEST RULES

1. Black and white, color prints or transparencies must have been taken between May [year] and September [year] to be eligible.

2. All print entries must be submitted as 8x10 prints with their negative. Slide entries must be the original slide.
3. Will be returned if a SASE is enclosed with entries.
4. The Omaha District, Corps of Engineers, reserves the right to use any photograph or slide entered in the contest, either in publications, displays, or slide presentations.
5. All photographs and slides will be judged on their quality and content by a professional photographer.
6. There is no limit on the number of times you may enter.
7. All entries must have contestant's name and address printed clearly on the back of each picture (on cardboard mounts of color transparencies) and be accompanied by an entry form or facsimile.
8. The categories are: Omaha District Projects, Wildlife, Flora, Recreation at District Projects, District Employees on the Job, and Human Interest.
9. The deadline for all entries is [date].
10. Be sure you know names and addresses of any recognizable persons appearing in your picture.
 No person may win more than one prize.
 Mail all entries to: Public Affairs Office, Omaha District, Corps of Engineers, 215 N. 17th St., Omaha, Neb. 68102.

ENTRY FORM

NAME, ADDRESS & TELEPHONE:_____

TITLE:_____
LOCATION TAKEN:_____
_____I hereby authorize the use of this
 (Signature)
photograph by the U.S. Army Corps of Engineers for all pur-
poses as stated previously. Any recognizable persons in your
photograph must sign the release form below.
_____I hereby authorize the release of my
photograph to be used by the U.S. Army Corps of Engineers.

SCHOLASTIC/KODAK PHOTOGRAPHY AWARDS

Comments. Annual contest; limited to students in grades 7 through 12, and under the age of 19.

This contest was established in 1962 and is one of the largest and oldest in the country. The sponsors are Eastman Kodak Company and Scholastic Magazines, Inc. The entry form is complete and entirely self-explanatory. Note, however, that the sponsors claim ownership of all winning entries, including original negatives and transparencies and picture rights (negatives need not be submitted except upon request).

For further information, including list of regional sponsors, and latest entry forms, write to:
Scholastic Photography Awards
50 West 44th Street
New York, NY 10036

SCHOLASTIC PHOTOGRAPHY AWARDS

Scholastic Magazines, Inc., is proud to present the [year] Scholastic Photography Awards program for the recognition of achievement by the nation's talented teenagers. For almost fifty years this program has encouraged creative expression among junior and senior high school students interested in photography. It is conducted with the cooperation of Eastman Kodak Company, the sole sponsor of the Scholastic Photography Awards. . . .

ELIGIBILITY

All students in grades 7 through 12 regularly and currently enrolled in public and non-public schools in the United States, its territories, U.S. schools abroad, and Canada are eligible. Any student over age 19 is not eligible. There are two groups for students entering work, based on grade: *Group 1* (Junior)—Grades 7, 8, 9; *Group II* (Senior)—Grades 10, 11, 12.

CLASSIFICATIONS

Group I—(Grades 7-9)
P-1. BLACK-AND-WHITE
P-1C.COLOR (Prints, Transparencies)
Group II—(Grades 10-12)
P-2. BLACK-AND-WHITE
P-2C.COLOR (Prints, Transparencies)
P-3. EXPERIMENTAL AND
 CREATIVE DESIGN (Black-and-White)
P-3C.EXPERIMENTAL AND
 CREATIVE DESIGN (Color)

(The National Association of Secondary-School Principals placed this program on the Advisory List of National Contests and Activities for 1978-79)

JUDGING AND NOTIFICATION OF WINNERS

Work will be judged by a group of recognized authorities and experts in the field of photography and their decisions both regional and national will be final. Regional sponsors will present the achievement keys, or else will send them with certificates to the principals. Winners of national honors will be notified through their *principal*, to whom Scholastic Magazines will mail the awards early in May.

REGIONAL HONORS

As a division of the Scholastic Art Awards program, the Photography Awards first give students in many areas the opportunity of winning honors in the regional exhibitions. Gold achievement keys and certificates of merit are awarded by regional sponsors. From the key-winning photos the judges will select "blue ribbon" finalists according to a national schedule of quotas based on population of regions.

Regional sponsors will forward the finalists to national headquarters at Scholastic Magazines to be judged for national awards. (In areas without regional exhibitions entries may be submitted directly to national headquarters for unsponsored preliminary judging as well as national judging.)

NATIONAL HONORS

Classification Awards
Up to 250 cash awards amounting to $7,500 are offered for both black-and-white and color photography. In Group I there will be two awards of $100 each given to the best entries in each of the two classifications. In Group II there will be four awards of $100 each given to the best entries in each of the four classifications. In both Groups I & II, there will be five awards of $50 in each of the 6 classifications. In addition, there will be up to 200 Honor Awards of $20 each distributed in the two groups.

Special Kodak Awards
Scholarship grants of $2,000 and $1,000 will be awarded by the Eastman Kodak Company to two seniors demonstrating outstanding photographic ability. Should the winners already hold scholarships, these grants will be applicable to other essential educational expenses.

Only seniors graduating in January or June [year] may apply. The grants will be awarded on the basis of portfolios.

Kodak Medallions of Excellence—A special medallion will be given for the best photograph from each sponsored region. The regional judges will nominate the *three best photos*. These will be identified in the regional exhibitions by a seal reading "Nominee for Kodak Medallion of Excellence." From these regionally nominated photos the national judges will then select one to receive the Medallion for each region.

Scholastic Magazines Scholarship Grant
A scholarship grant of $500 will be awarded by Scholastic Magazines to a scholarship candidate showing outstanding photographic ability. (Awarded on the basis of portfolio.)

NATIONAL RECOGNITION

Kodak will sponsor an exhibition of the prizewinning photographs in New York City. Exhibition dates and place will be announced. A selection of prize-winning prints will receive further recognition through a traveling exhibit prepared by Eastman Kodak Company, which will tour U.S. schools and will later go to foreign countries.

GENERAL RULES

1. All photos submitted must have been taken by the entrant after January [year].
2. All black-and-white photographs and color prints must be *enlarged and mounted or matted.* Mount or mat must be white, gray, or black no smaller than 11 x 14 inches and no larger than 16 x 20 inches. (Prints must be at least 30 square inches; e.g. 5 x 6.)
3. The entry blank, typed or hand-lettered, must be filled out completely and affixed to the back of mount of each black-and-white photo and color print. (See sample entry blank, page 7.)
4. Each color transparency must bear on *its mount* the student's name and the classification number of entry (also entry title if possible). Enclose *each transparency* in a 6 x 9 inch manila envelope, and paste entry blank on front of envelope.

For required entry blanks, write after December 1 to Regional Sponsor. If your school is not in a sponsored region, write after December 1 to Scholastic Photography Awards, 50 W. 44th St., New York, New York 10036. Specify the exact number needed. Since the Scholastic Awards program emphasizes originality and craft, students are encouraged to submit photographs which reflect their own skills. All entries must have been taken by students submitting work and not copied from another person's photograph.

SPECIAL REQUIREMENTS

1. All photos that receive national cash awards or Medallions of Excellence become the property of the sponsor, including original negatives and transparencies, and picture rights. Send negatives only when requested to do so.
2. Also, students who win national awards will be required by the national sponsor to forward original negatives and transparencies after national judging. If these are not received by specified deadline entries will be disqualified.
3. If recognizable people appear in your proposed entries, be sure to have their names and addresses. Written consent of any recognizable person or persons must be obtained before a national award can be given. This is necessary for national display or publication purposes. (Forms are only needed when requested by national sponsor.)

HOW TO SUBMIT ENTRIES

1. First check to see if your school is in an area where a *regional exhibition* will be held. If your school is within the listed regions, entries and portfolios must be submitted for preliminary judging to these regional sponsors at time indicated.
2. If your school is in an area *without a regional sponsor* entries and portfolios must be sent directly to Scholastic Photography Awards, 50 W. 44th St., New York, N.Y. 10036, to arrive during the period of February 1 through February 16. (No entries will be accepted after February 16.)
3. Students in areas without regional sponsors may submit up to 10 individual entries or one portfolio. In areas with regional sponsors, students should check with their teachers for possible local entry quotas.

HOW TO PREPARE A PORTFOLIO

(Scholarship Grants—Seniors Only)
Write well in advance to Scholastic Photography Awards, 50 West 44th Street, New York, N.Y. 10036, for *Photography Scholarship Application Form.*

Each portfolio must contain exactly 12 photographs. A minimum of 6 black-and-white entries must be included. The judges expect variety in subject matter, style, and technique.

All entries must be prepared in accordance with the rules. (After the scholarship judging, selected entries will be judged in the individual classifications.) Each student may submit only one portfolio.

Send all work in a hard-cover portfolio large enough to enclose your photographs. On inside front cover, paste a manila envelope containing: (1) scholarship application form, including sealed recommendation filled out by teacher; (2) sealed transcript of your high school record.

REMINDERS TO TEACHERS

1. Address package of entries clearly to proper place. See "How to Submit Entries." Hand-letter your school and its address in upper left hand corner of package.
2. In selecting entries for submission to the Scholastic Photography Awards, do not include pictures, or a closely similar picture of the same subject, which is intended to be entered in

any other competition—or was entered in a previous Scholastic (Photography) Awards competition.
3. Do NOT submit photographs for which your student will be unable to obtain written consent from recognizable person(s) appearing in photograph.

RETURN OF ENTRIES

1. All entries not winning national awards will be returned to teachers as soon as possible after judging.
2. Scholastic Magazines and the national and regional sponsors assume no responsibility for the loss or damage of entries.

PHOTO TALENT ASSOCIATES CONTEST

Comments. One-time contest, open to everyone.

This contest has been discussed elsewhere in the book (see chapters 4 and 8) to illustrate several types of problems that can arise. Note in particular rule 7, regarding the sponsor's use of the photographs. Also, as has been mentioned previously, the prizes in this contest were not entirely what they appeared to be.

PHOTO TALENT ASSOCIATES CONTEST

101 Award Prizes—Plus Every Entrant a Winner!

5 CONTEST CATEGORIES

- Scenics—nature, land & cityscapes
- Animals—all species
- Human interest—People, their actions, emotions, relationships
- Sports
- Art Photography—surreal and abstract

An award will be given in each category for b/w and color (prints or slides). However, there will be only one Grand Windjammer Prize.

PRIZES! PRIZES! PRIZES!

MOST IMPORTANT—Every Prize Winner from Grand to Fourth will have the honor of being exhibited at world-famous **IMAGES** . . . the gallery of contemporary photographic art. This gives you the opportunity to display your work to the public and media in most prestigious surroundings.

GRAND PRIZE

WINNER'S EXHIBITION IS DEDICATED TO YOUR WORK with the "Lion's Share" of Exhibit Space yours as you are the "lion" of the day! PLUS a fabulous Picture-Taking Adventure—The WINDJAMMER CRUISE on a great sailing ship to share in the mastery and mystery of the sea.

10 FIRST PRIZES 5 B/W 5 Color
each category wins FABULOUS NIKON FM plus exhibit

10 SECOND PRIZES 5 B/W 5 Color
each category wins NEWEST ROLLEI LED plus exhibit

10 THIRD PRIZES 5 B/W 5 Color
each category wins KONICA EPP plus exhibit

10 FOURTH PRIZES 5 B/W 5 Color
each category wins ULTIMA PR 200 plus exhibit
Prize-winning pictures will be printed in exhibition size for exhibit and shown for one full month or more.

60 HONORABLE MENTIONS—win AN ULTIMA PR 100. Although these winners do not qualify for exhibit, they will receive a certificate of mention and a commendation to the photographic press.

AND EVERYBODY WHO ENTERS WINS!

Your entry blank earns you over $100 in discount coupons redeemable by mail for brand name services and products. Save on books, instant cameras, pocket cameras, 35mm cameras, much more. Real dollars-off on the most popular names—Kodak, Rollei—and you don't have to come to New York to cash in.

CONTEST RULES

1. Contest is open to anyone except PTA and IMAGES employees and their families.
2. Entries may be unmounted b/w or color prints up to 11x14 or any color slide, not previously published.
3. Every entry must carry the name of the submitter and contest category on back of print or on mount of slide.
4. No more than 3 entries per person will be considered.
5. If required by law, a model release where applicable must be in possession of the photographer.
6. All prints and slides will be returned if accompanied by necessary return postage, except those selected for PTA stock library.
7. Each entrant agrees that any print or slide entered may be accepted by PTA for inclusion in stock library; to accept fees negotiated by PTA for use; and to permit PTA to charge its normal agent's commission on fees received.
8. FEES—1st Entry, $5.00; 2nd Entry, $3.00; 3rd Entry, $2.00.
9. A list of winners will be furnished to anyone requesting it with a stamped, addressed envelope.
10. Panel of judges will consist of gallery directors and prominent professional photographers whose decisions will be final.
11. All entries must be postmarked on or before (date) and mailed to: PHOTO TALENT ASSOCIATES, BOX 5262, FDR Station, New York, N.Y. 10022.

CONTEST VOID WHERE PROHIBITED.

DON'T MISS YOUR CHANCE TO BE A STAR! And be exhibited in this leading gallery which has shown the works of Ernst Haas, Jay Maisel, Robin Perry, Robert Farber, Michael DeCamp, Mitchell Fund, Pete Turner and David Hamilton. It's your chance to enter the big time—New York's "Gallery Row" on 57th Street.

If coupon is missing, mail entries and payment to:
PHOTO TALENT ASSOCIATES, 127 East 59th Street, New York City 10022

MAIL IN YOUR ENTRIES AND THIS ENTRY BLANK TODAY!

To: PHOTO TALENT ASSOCIATES, P.O. Box 5262. FDR Station, NY 10022.

I am submitting the entry(s) listed below for your PHOTOCONTEST. If my work is selected as a winning entry, I hereby grant to PTA and Images Gallery the right to exhibit, reproduce and publish my work for any promotion, advertising and publicity purposes: to use my name, likeness and biographical information therewith. I have signed the entry below to indicate my consent. (Minors must have parent or guardian sign for them.)

NAME_____

ADDRESS_____

CITY_____State_____ZIP_____

Entry #1 Entry #2 Entry #3

Category_____Category_____Category_____

slide__print__size__print__size__slide__print_____

$5.00 $3.00 $2.00

☐ I enclose payment of_____or ☐ charge my

 Master Charge #_____expires_____

VISA #_____expires_____

SIGNATURE_____

ENTRANT'S CONTEST #A- (do not write here)_____

AMERICAN KENNEL CLUB PHOTO CONTEST

Comments. One-time contest, open to everyone.

Special-interest organizations and publications run contests like this one from time to time.

Note rule 3, which claims sponsor's ownership of winning entries. In response to a query regarding this stipulation, the assistant to the President of AKC replied:

As to rule number three, it is stated that way so that entrants understand that they are surrendering complete rights to us. We have done this to avoid any possible conflicts in the future. ... What do we intend to do with the pictures? Probably we will

publish them in the magazine. We may make a display of them and exhibit them in our offices. Other than that we do not have any express uses in mind at this time.

The American Kennel Club is a nonprofitmaking organization with a good reputation. You must decide for yourself whether you wish to submit to this regulation; understand, however, that under copyright law, your photographs belong to you less *specific* rights are *signed away.*

Also note in this form that the number of certificates of merit to be awarded is not stated. Any photograph receiving a certificate of merit is considered a prizewinner and thus open to the sponsor's claims.

Finally, you might ask yourself why, if the sponsor intends to use the photographs only as stated, it demands all rights to the pictures.

THE AMERICAN KENNEL CLUB PHOTO CONTEST

For the first time The American Kennel Club has decided to sponsor a photographic contest. The subject: *man's best friend.* There will be two divisions, color and black and white. The top prize in each category is $250.00. There will be a second prize of $150.00 and a third prize of $100.00 in each division. Additionally, the judges will award Certificates of Merit of as many other entries as are found deserving.

The contest is open to everyone except employees of The American Kennel Club and their immediate families. Entries may be submitted between May 1, (year) and December 31, (year). Winners will be announced in early (year).

For this first contest it was decided to keep the categories as broad as possible in order to stimulate a wide selection of entries. This is the reason the contest's divisions were merely color and black and white. So long as the picture features a purebred dog it is a possible entry for our contest. Photographs should focus on the relationships between dogs and people. The winning entries will be published in the *Gazette* in the Spring of 1980

and exhibited in the Library and offices of The American Kennel Club at 51 Madison Avenue.

We hope all *Gazette* readers with an interest in photograph, as well as photographers who are not fanciers, take up the challenge of this contest. We look forward to receiving entries and hope the results will enliven the pages of future *Gazettes.*

Remember the absolute deadline is December 31, (year). Be certain to put your name and address on every entry and if you want your picture returned it is essential to include a stamped, self-addressed envelope.

PHOTO CONTEST RULES AND REGULATIONS

1. The contest is open to anyone, amateur or professional photographers, except employees of The American Kennel Club and their immediate families.
2. Only previously unpublished pictures may be entered. Each person may submit up to three entries in each category.
3. All winning entries become the property of The American Kennel Club, which acquires the right to publish, exhibit and use them in any manner it so chooses. Other entries will be returned only if the entrant requests their return in writing, and includes a stamped self-addressed envelope. AKC will not be responsible for lost or damaged entries under any circumstances.
4. Entries may be transparencies or prints up to 11" x 14". Every entry must have the name and address of the photographer printed on or taped to the back of the entry.
5. All entries must be received by *Pure-Bred Dogs/American Kennel Gazette* on or before December 31, (year).
6. The winners will be chosen by a committee selected by The American Kennel Club. Decisions of the judges are final.
7. Send all entries to:

Pure-bred Dogs/American Kennel Gazette
Photography Contest
The American Kennel Club
51 Madison Avenue
New York City, NY 10010

MILK-BONE CANINE CAPERS CONTEST

Comments. Was held only once. Contest was open to amateurs only. Manufacturers of different products run contests from time to time to publicize their merchandise; the photographs may be used for advertising and promotional purposes.

The following announcement, with the Editor's note, appeared in *Photo Insight* (see chapter 3).

MILK-BONE CANINE CAPERS PHOTO CONTEST

Closes: January 16

Grand Prize $10,000 Cash
1—Second Prize $1,000
3—Third Prizes worth $586.90
30—Fourth Prizes worth $69.50
100—Fifth Prizes worth $29.50

RULES: 1) Take a photo of your favorite dog—running, playing, or just being affectionate. 2) Each Entry must include the entrant's name, address and zip code printed on the reverse side of the photo. 3) All photographs must be original. 4) More than one entry may be submitted, but each must be in a separate envelope. 5) Include with each entry a box top from any Milk-Bone product. 6) Photos may be black & white or color. 7) No larger than 11x14 or smaller than 3½x3½ will be eligible. 8) Transparencies, slides, composited or montages (combining separate pictures) are ineligible. 9) Professional photographers are not eligible. 10) No entries will be returned and become the property of Nabisco, Inc. 11) All prizes will be awarded.

The judges will be considering factors such as appropriateness, interest, creativity and uniqueness.

Residents of the U.S. and its territorial possessions are eligible to enter. Employees and family members of Nabisco, Inc., or any of its advertising or promotional agencies are not eligible.

MAIL TO: Canine Capers Photo Contest
P.O. Box 3482 PL
Grand Central Station,
New York, New York 10017

EDITOR'S NOTE: Needless to say, this contest would not have been recommended because of Rule #10—But for ten thousand dollars in cash, you would not have listened to me.

AUTHOR'S NOTE

And now, with all the foregoing information, you are prepared to enter the exciting world of photographic competition. Now, you can pick a contest you feel you can win; fill out the entry form; select your best photographs; then wait for the judges's decision.

My best wishes for your success. May you have the exhilarating experience of being a winner.

But if you don't win, remember, that you've tried your best and met the challenge—and that's a prize in itself.

Lida Moser

Index